Imari

FAMOUS CERAMICS OF JAPAN 6

Imari

Takeshi Nagatake

KODANSHA INTERNATIONAL LTD.
Tokyo, New York, San Francisco

distributed in the United States by Kodansha International/USA, Ltd.,
through Harper & Row, Publishers, Inc., 10 East 53rd Street,
New York, New York 10022

published by Kodansha International Ltd., 12–21 Otowa 2-chome,
Bunkyo-ku, Tokyo 112 and Kodansha International/USA, Ltd., 10 East
53rd Street, New York, New York 10022 and 44 Montgomery Street,
San Francisco, California 94104

LCC 81–85011
ISBN 0–87011–487–5
ISBN 4–7700–0974–7 (in Japan)

Imari

Compared with the pottery of other Japanese kilns, Old Imari wares are uniquely bright, vigorous, and varied, and it is clear from their colorful historical background that they were close to the hearts of the Japanese people of the Edo period (1615–1868). It is not just that this pottery was made to fit Japanese taste; Old Imari was also treasured abroad. Originally, the skills that were used to make these wares were introduced from abroad—the techniques found nourishment in the province of Hizen in northern Kyushu, and Imari ware was born. It proceeded to create its own tradition and own characteristic style and developed a very Japanese type of cobalt-blue decorated porcelain (*sometsuke*) together with polychrome enameled porcelain (*iro-e*) in response to domestic and overseas market demands.

Porcelain was first produced in the Arita area of Hizen Province at the end of the sixteenth century (Momoyama period). It developed rapidly during the early part of the seventeenth century (early Edo period) and subsequently has continued to mature. The porcelain takes its name "Imari" from the port from which it was shipped.

The Establishment of Hizen Porcelain

The Japanese are said to be extremely sensitive to the beauty of ceramics. Certainly, they were fond enough of cobalt-blue underglaze decorated porcelain to encourage its domestic production in the early decades of the Edo period, when the country rallied after years of civil war and enjoyed the beginning of a peaceful era. Porcelain production was established in the region of Arita, on the western border of the province of Hizen, perhaps as a means to enhance the prosperity of the region.

There is some difficulty in ascertaining the exact origin of Imari ware. The generally accepted theory is that a Korean potter, known as Ri Sampei, was brought over to Japan in 1594. He has been thought to have built the very first porcelain firing kiln in 1616, and the kiln site has been fixed as that at Tengudani in Kamishirakawa in the Arita region.

Ri Sampei eventually became a naturalized citizen of Japan, taking the name Kanagae Sanbei, and subsequent generations of his family worked for the Nabeshima clan in Hizen Province.

Recently, however, a new theory has been proposed, suggesting that porcelain was fired from as early as 1605, setting back the dawning of Japan's porcelain industry by a decade. This means that research will have to be done on the possibility that another group of potters settled in Japan at the same time as Ri Sampei and discovered deposits of porcelain clay. At any rate, this new theory is based on a petition found in a priceless document known as the *Arita Sarayama daikan nikki*. This document was discovered in the Nabeshima fief archives and relates that a group of potters led by the master craftsman Ienaga Shōemon founded a kiln at "Shirakawayama, Tengudani" well before the hitherto accepted date of 1616, and this suggests that porcelain was made there. Shōemon was the grandson of Ienaga Hikosaburō, who had been especially licensed by Toyotomi Hideyoshi as a "master potter," and it appears that Shōemon was in charge of a group of potters who fired "Nanking style porcelain" at Tengudani. Not only this, but the document makes it clear that Shōemon and his group were obliged to move elsewhere when a group of Korean potters in the Taku area came to work at Tengudani, where Shōemon had built his kiln.

There is a petition about this lodged by the descendants of Ienaga Shōemon and mentioned in the *Arita Sarayama daikan nikki*. This is a semiofficial document in that it records memos made by officials in charge of Arita Sarayama. It seems that Ri Sampei, together with other leading members of a group of Korean potters, was in charge of the porcelain clay deposits of Izumiyama. Upon moving from the Taku area, they came to Tengudani and rebuilt the kiln estab-

lished there by Ienaga Shōemon. They then proceeded to concentrate on the production of porcelain there. This record makes it necessary to reconsider the hitherto accepted date of 1616 for the foundation of porcelain production in Japan.

The Korean potters built a whole series of kilns along the slopes of Tengudani valley. Although the potters appear to have produced a wide range of pots, in due course they adapted the wares to suit the taste of the time. They endeavored to improve both forms and designs, and their work developed from a mid-Yi dynasty style to a Ming dynasty Chinese style of porcelain. Patterns and designs found on wares made during the Genna (1615–24) and Kan'ei (1624–44) eras are similar to those of Yi dynasty porcelain, but in the very short period from the mid 1630s to forties they changed entirely to a decorative Chinese porcelain style.

The Arita region, where porcelain was made, was under the jurisdiction of the Nabeshima fief, and for administrative purposes, the area was divided into the Uchiyama (Inner Mountain) and Sotoyama (Outer Mountain) districts. These terms have now been adopted to distinguish the pottery made there. What is known as Arita Uchiyama porcelain was for the most part produced in kilns that specialized in porcelain production and that only fired stoneware pottery in very small quantities for an extremely limited period of time. The Sotoyama kilns, on the other hand, started by firing stoneware; porcelain was gradually introduced before the kilns finally ended up producing porcelain only. Many of these kilns, however, were active for only a short time. The group of kilns at Kotōge, in the north of the Takeo district, and the famous early porcelain Hyakkengama kilns near Arita fired both stoneware and porcelain, but the Arita Uchiyama wares include many shapes and types of pot, with such established types of glaze as celadon, cobalt blue (*sometsuke*), black (*temmoku*), and white porcelain. Particularly remarkable are the Chinese Ming dynasty techniques that were adopted from early on—sprayed cobalt, bluish and greenish white porcelain (*seihakuji*), and incised pieces. When these pots are compared with those first produced in Sotoyama, one can see that the latter are much simpler and less varied in design; they also make use of a somewhat less pure cobalt in their *sometsuke*. There is not such a wide range of wares produced at Sotoyama, the clay used for throwing is rich in iron, and the

colors are often overfired or underfired. However, the craftsmanship, forms, and motifs used at Sotoyama compare very favorably with those adopted by potters at Uchiyama.

Early Imari

Generally speaking, the cobalt-blue decorated (*sometsuke*) porcelain that is nowadays referred to as "Early [*Shoki*] Imari" should perhaps be more strictly termed "Early Arita." Certainly, there is a difference between "Early Imari," or "Early Arita," and "Old [*Ko*] Imari" wares, for the latter have gone beyond the Korean Yi dynasty style and make use of Chinese Ming and Ch'ing dynasty techniques, which involve mass-production methods. Early Imari may be further categorized into a period in which techniques were being developed and another in which wares were produced in considerable quantity.

The first period, that of technical development, occurred between 1620 and 1628. It was during these years that potters seem to have experimented with refractory materials and redesigned their kilns, for there is evidence to show that kiln loading tools, stilts, and other materials were all tested. The forms and glazing of wares continued in much the same way as before, and the color of cobalt underglaze improved. The percentage of successful pots in each firing increased during this period, and a wide variety of pottery types was fired. Characteristic of the wares produced during these years are tall pots, such as bottles with high foot rims. Designs tended to be influenced by late Ming dynasty Chinese wares, rather than by the hitherto predominant Yi dynasty style.

The second period, during which pots were produced in quantity and little experimentation was done is between about 1629 and 1643. It is characterized by stability in firing techniques and a set style showing the influence of late Ming dynasty *sometsuke* porcelain. Consequently, there was an increase in demand, which led to the Arita Sotoyama kilns turning from the production of stoneware and joining the Uchiyama kilns in the firing of porcelain, so that the whole of Arita now started mass production. In 1637, the lord of the Nabeshima fief, Katsushige, ordered his senior administrator (*bugyō*), Taku Shigetoki, to protect the naturalized Korean craftsmen, to improve the quality of porcelain, and to preserve the secrecy of techniques. It was from this time that the Nabeshima fief was able to virtually monopolize porcelain pro-

duction in Japan, since it spared no effort to watch over the potters working within its domains and persisted in protectionist policies. Trade was at first conducted with China and Southeast Asia from the port of Hirado, in the nearby district of Matsuura, but in 1641 the port was changed to Nagasaki Dejima, where the Dutch East India Company shipped to overseas markets. Local business was conducted by shipping wholesalers who were centered in Imari and who shipped Hizen porcelain to various parts of Japan.

By this time, all sorts of everyday wares were being produced, so that even though the original Yi dynasty style pots, typical of the very beginning of porcelain production in Arita, lingered on to some extent, they were generally superseded by wares revealing a craftsmanship and design that was more Chinese than Korean in style. Moreover, glazes ceased to be applied to green (unfired) pots. Rather, the technical improvement of painting cobalt decoration on biscuit-fired pieces then applying the transparent glaze was adopted. Again, it was during this period that the economic organization of each pottery workshop was based on somewhat feudal lines, with a system of labor division

being installed. Thus, a kiln owner employed throwers, decorators, modelers, and general workers—all of them specialists in their own fields.

Old Imari
While there is no need here to make any further distinction between Early and Old Imari wares, it might be noted that, although Early Imari wares consisted almost entirely of cobalt-decorated porcelain, Old Imari included polychrome enameled wares as well as various forms of cobalt-and-enamel (*somenishiki*) decorated pots with five-color (*gosai*) glazes and gold and silver painted on a cobalt underglaze decorated body. It was in this Old Imari period that the potters developed the Ming dynasty decoration styles and pot forms into wares for which there was high demand, both inside and outside Japan.

Kilns firing Old Imari porcelain extended beyond Arita Uchiyama and Sotoyama districts to cover the broad region of Ōsotoyama in the Saga fief. There is something international in feeling about these wares —not just in the vigor and variety of shapes, sizes, motifs, and designs, but in the nature of consumer demand for them and in the methods by which they were marketed.

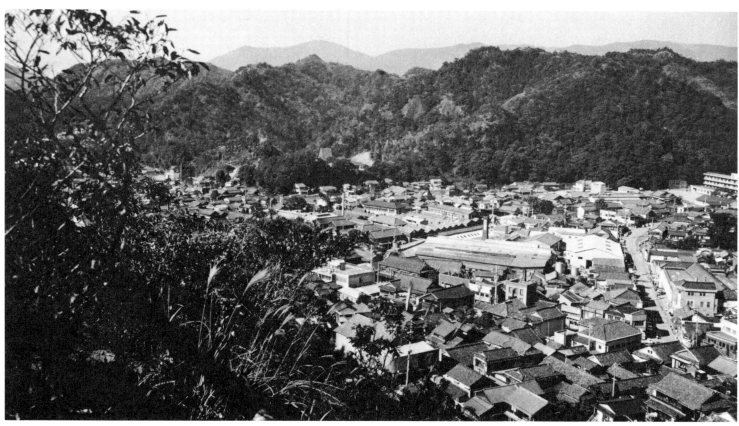

A view of the town of Arita.

Old Imari—Early Period

The early period of Old Imari is between 1644, when the art of porcelain making had been mastered and the kilns of Arita Sarayama were in regular production of Japan's first polychrome enameled porcelain, made under the protection of the Nabeshima fief, and 1660, when the Dutch East India Company first began trading in Imari ware. While these Old Imari pots of the early period retained certain Chinese Ming dynasty traits, they gradually acquired a more typically Japanese style, assimilating influences from the ink painting of the Muromachi period (1333–1573) the opulent screen and sliding-door paintings (*shō-heki-ga*) of the Kanō and Tosa schools of painting, contemporary popular illustrated books, and the gold lacquer ware (*maki-e*) of the time. The brushwork on the pottery of this time displays what is now seen as a characteristically Imari strength, while the pots themselves—in comparison with the dishes, bottles, and bowls of the Early Imari wares—became much larger, with big bowls (both molded and thrown) and square bottles being made in quantity.

Old Imari—Golden Age

Mainly as a result of the development of a more purely Japanese style of polychrome enameled porcelain, there was an increase in the commercial value of Old Imari pottery during its early period. Consequently, potters were able to fire their kilns secure in the knowledge that their work would sell. This commercial success of Old Imari porcelain ushered in its Golden Age. Hizen porcelain now took over a leading position in the world pottery market, previously monopolized by Chinese porcelain in the early part of the seventeenth century.

One reason underlying the growth in production can be attributed to the general peace and prosperity pervading Japanese society. From about 1661 to 1672, the Nabeshima fief was able to increase porcelain production, and a larger number of Dutch ships began to put in at the port of Nagasaki Dejima. In 1672, eleven households of polychrome enamel decorating specialists were brought together by the fief authorities in Arita Uchiyama, and after this the Nabeshima fief was able to monopolize the production of extremely high-grade work, supporting the 150 pottery households in and around Arita Sarayama. In 1693, the second lord, Nabeshima Mitsushige, had a design copybook distributed in Sarayama; he also strengthened his con-trol over the pottery workshops and gave concrete instructions about how standards should be improved. By the time the third lord, Tsunashige, took over, the Nabeshima fief controlled the economic management of the Arita porcelain industry, and extremely decorative Imari wares were being produced.

The real question, however, is how Old Imari wares came to occupy such an important place in the world pottery markets. Here, the part played by the Dutch East India Company cannot be over-stressed, although, of course, such prosperity in some way or another is also the result of fortuitous circumstances. Imari porcelain appears to have been particularly fortunate in this respect. First of all, Japanese porcelain was initially taken up by foreign traders because of the political turmoil and economic change occurring in China at the end of the Ming dynasty. These disrupted the production of porcelain there and made it impossible for Chinese potters to continue to satisfy world demand. Thus, the monopoly that they held in the porcelain trade in Southeast Asia and Europe during the whole of the sixteenth century now came to an end. It so happened that Hizen porcelain was at this time just reaching its peak and was capable of satisfying the European market in both quantity and quality. Members of the Dutch East India Company were quick to realize this and began shipping Old Imari along their customary trade route from Japan to Europe.

Secondly, the production of porcelain at Arita was further favored by domestic circumstances—in particular, by changes in living standards. During the Muromachi, Momoyama, and early Edo periods, eating and drinking utensils were predominantly lacquer ware. Porcelain was limited to things for use on special occasions by wealthy noble and military families. However, by the eighteenth century (mid-Edo period), the so-called popular culture had spread over the country from Edo (present-day Tokyo) and Kyoto. As the country's prosperity and the power of the merchants and townspeople increased, so did the demand for porcelain.

Whereas traditionally potteries producing stoneware for everyday use worked on a seasonal basis in which farmers made pots when not engaged in farming, the typical Imari porcelain workshop came to be centered around a "kiln owner" (*kamamoto* or *kamanushi*). He employed specialist craftsmen to throw or form, decorate pots, and fire the kilns. Porcelain

predominantly was now made to fill orders from Japanese and foreign customers. It was from this period also that porcelain was treated as high-quality merchandise and marketed in a cash economy both domestically and overseas. In this, it differed considerably from stoneware pottery, which was still in general being traded in a barter exchange system.

Old Imari—Late Period

Old Imari wares reached their peak in the mid 1760s. By this time, demand was so great that porcelain wares were mass produced and used by all classes. Porcelain wares became part of the lives of the people and were *used* rather than looked at; Imari wares were no longer the objets d'art that they had been in the past. Perhaps as a result of this shift from decorative to functional pots, workers did not take so much care in the production of wares, and it can be seen that the overall quality of Imari porcelain began to decline. From 1764 to 1827 or so, it entered a stage of "overmaturity."

It was at this time that pottery dealers trading out of the port of Imari obtained permission from the lord of Saga (in whose fief, it will be remembered, Imari lay) to market pots to the provinces through official clan channels. Mass production was increased even further, and porcelain was even shipped to Korea. The negative result of this, however, was that the eleven households that had specialized in polychrome enamel decoration were unable to keep up with the increased demand, and five new households had to be added to their number in 1770. At the same time, the number of officially recorded kiln operators increased from 150 to 220.

Naturally, the opening up of the market for porcelain affected the kinds of pots that were made. Unlike Chinese porcelain, Japanese porcelain was now being used and admired by the ordinary man in the street, and all sorts of functional shapes—oil lamps, *choku* cups, saké drinking sets, and so on—appeared. It was from this time, too, that the opulent, decorative style known as *kinrande*, using gold and overglaze enamels, came to be used on lidded objects, jars, bowls, and so on. Today this ware might seem somewhat overdecorated. However, it should be realized that *kinrande* was merely following one general trend in craftwork of the time—this trend can also be seen in the luxurious dyed and woven designs of late eighteenth century textiles.

So Old Imari wares finally entered their period of decline, with the great fire that occurred in Arita Sarayama in 1828 being primarily responsible for the ensuing instability. Between 1830 and 1843, style, quality, and production all deteriorated rapidly. Imari ware was no longer considered to be an objet d'art, and many potters and decorators who had lost their homes and workshops as a result of the fire moved away to Sotoyama and Ōsotoyama. Things were so bad, in fact, that the Nabeshima lord of that time, Naomasa, proposed a loan of over three hundred *ryō* in gold and planned to distribute excess rice from the clan's storehouses in order to help the workshops in Arita Sarayama along the road to recovery. Naomasa's policies had the desired effect. Internal land and sea communications were greatly improved, and Arita Uchiyama's production began to recover. Porcelain became even more popular with the masses, and there was a sharp increase in the demand for everyday wares.

The craftsmanship and design of Old Imari in its late period followed several new trends, anticipating, perhaps, the new age that was about to dawn in Japan. The mood of society at this time is perhaps best reflected in the "map" plates, which were extremely popular. As well as these "map" plates produced during this period, large *sometsuke* plates were made in great numbers. One reason for their being so popular is that, despite the somewhat unsettled state of Japan at the beginning of the nineteenth century, popular culture itself was flourishing. From city dwellers to farmers and fishermen, when people gathered on festive occasions, more and more frequently these gatherings were accompanied by saké drinking. Large plates were necessary on which to serve food with the drink. There was thus a continued demand for large platters, varying in size from fifty to eighty centimeters in diameter, and these were made in Arita Sarayama in large numbers.

Imari Revival Period

There were several incidents right at the end of the Edo period, between 1848 and 1859 (the Ka'ei and Ansei eras), when the central government authorities in Edo were forced to allow American, French, British, and other foreign vessels to trade with Japan. As a result of these incidents, which are generally referred to in Japan as the arrival of the black ships, the Dutch government ended up, in 1855, in stopping

vessels of the Dutch East India Company from putting into Nagasaki Dejima. Both the ships that came from abroad and the foreigners on board them were frequently depicted on the *sometsuke* porcelain made during these decades.

Trade with Southeast Asia and British interests was to a large extent conducted through wholesalers, for at this time the wholesaling system thrived in Japan. A Hizen wholesaler set up in Edo, and a Saga Fief Merchants' Association established itself in Nagasaki, while in Arita itself porcelain merchants such as Tashiro Monzaemon of Honkōbira and Hisadome Yojibei of Nakanohara obtained permission from the Nabeshima fief authorities to trade directly with retail outlets within Japan, thus boosting the domestic market, and to deal directly overseas, thereby developing international trade. Indeed, the Nabeshima fief's hitherto firm grasp on production and its protectionist policies weakened somewhat in both the Uchiyama and Sotoyama districts from around this time, and the system of officially registering polychrome enamel decorators now become little more than a formality. As a result, there emerged what are known as the secret enamel painters, who made officially banned enameled porcelain at the Yagenji kiln in Arita Sotoyama and other kilns in the neighborhood of the Toshiki Valley near Izumiyama.

In 1867, a large polychrome enameled decorative jar with flower-and-bird design made in Arita Sarayama was displayed at the world exposition in Paris. Important samurai of the Saga fief took this opportunity to join other samurai from Satsuma in southern Kyushu to make a pioneering trip to Europe and hence lead the rest of Japan.

Old Imari Kilns

A fairly rough distinction can be made between Uchiyama, Sotoyama, and Ōsotoyama wares.

Uchiyama covers the eastern regions of modern Arita-machi and in the past included all the kilns situated within a radius of two kilometers from the Sarayama magistrate's office. This area had pine-covered mountains during the early stage of porcelain production. Then porcelain clay was discovered at Izumiyama, production began at Kamishirakawa, and the nature of the area changed considerably. Uchiyama kilns spread out from Kamishirakawa to Kodaru, Izumiyama, Hiekoba, and the Sarukawa valley. There are also kiln sites at Iwayagawachi, Ō-

daru, Nangawarayama, and so on, but these are not usually included within the general classification of Uchiyama kilns. Within Uchiyama are to be found the clay deposits of Izumiyama, the enamel decorators' area (*aka-e machi*), where the officially registered overglaze enamel painting specialists lived and worked, and the magistrate's office. The Uchiyama area may justifiably be seen as the locus of Arita's porcelain production. It is also the religious center of the Yi dynasty Korean potters who came to Japan in the late sixteenth century: the Kanshō-ji temple (generally regarded as the potters' ancestral shrine) and the Hōgen-ji temple (to which prayers were offered for the safety of potters firing kilns) are both to be found in the Uchiyama area. The kilns there include that worked by the Tsuji family, who fired pots for use by the imperial household in Kyoto, together with other kilns that made high-class art porcelain and dinner service sets known as "presentation Imari" (*kenjōde Imari*). The potters working these kilns were given favorable treatment and were allowed to make use of the best-quality clay available at the Izumiyama deposits.

The Sotoyama region contains Ōhōyama and Hiroseyama at its center and covers a broad area, including the Kuromuta and Yamabeta districts. Porcelain fired at the Kakenodani and Hirose kilns during the formative period of Sotoyama wares was influenced by pieces made during the formative period of many of the Uchiyama kilns, most of which were started during the second quarter of the seventeenth century (Kan'ei era). Kilns firing in the Ōhōyama area mainly produced domestic altar bottles, small bottles, oil jars, and so on; those in Hiroseyama, on the other hand, fired small bowls, square *donburi* bowls, and so on. Pressed wares—bowls, square dishes, and plates—were among those everyday utensils fired at the Sotoyama and Kuromuta kilns. The Yagenji and Kōraijin kilns at Ōhō, which are thought to have been built in the eighteenth century, fired oil jars, large and small bottle shapes, and square dishes during the late Old Imari period.

The Ōsotoyama area included stoneware kilns that fired porcelain as well, in the districts of Takeo, Hasuike, and Kashima. While they were given permission to use the clay from the Izumiyama clay deposits, they were only allowed to take rough-grained, low-quality material.

The Beauty of Old Imari

Enameled Hizen porcelain was perfected around the middle of the seventeenth century, but the commercial style of this large porcelain producing area was limited to that of Old Imari. This consisted of cobalt underglaze decorated wares as well as of polychrome and gold enamels over the cobalt underglaze. Such ware was not produced by a simple, family-style cottage industry system, but, rather, gave rise to a premodern system of industrial organization utilizing division of labor.

Old Imari exhibits a number of characteristics. Firstly, wares were almost inevitably based on Chinese porcelain prototypes and were fired to special order of local shipping agents, financiers, and wholesalers, who thus insured that the wares were marketable and in style. Thus, the earlier Chinese style enameled porcelains were gradually replaced by wares more Japanese in style. In the Chinese style, the decoration of each pot is divided into five sections—one pattern being found in the center of the upper surface, another around the center, a third around the rim, a fourth on the underside of the belly, and the fifth on the pot's foot rim. Most patterns found in the center of the pot's upper surface were Chinese style landscapes, auspicious characters, such as those signifying "long life," "prosperity," "happiness," and so on, or bird-and-flower designs or designs including Chinese men. Patterns around these central motifs, together with those around the rim of the pot, were mainly repetitive floral motifs. This gave each piece a stable formality in feeling.

The vast increase in demand for bowls can be seen in the fact that deep bowl shapes began to be mass produced, being mold-formed rather than thrown on the wheel. After the beginning of the eighteenth century the Japanization of designs proceeded even further. They were clearly influenced by *ukiyo-e* woodblock prints and genre painting, bird-and-flower painting, copybooks, and styles of that period. Even so, the results could not be called totally Japanese, for craftsmen still relied on an essentially Chinese style for decorating lids, mouths, and shoulders of jars. Indeed, one should perhaps say that it was precisely because these Chinese traits were retained that porcelain pots sold so well. In addition, Chinese style patterns and designs were drawn around pictorial Japanese motifs, so that Old Imari wares should be seen as a composition of various types of design. The Old Imari style might perhaps seem somewhat over-ornamental, but it should be realized that this decorative aspect followed the popular designs found in the gold and silver inlaid *maki-e* lacquer ware and the dyed fabrics of this period.

The Hizen Porcelain Trade

The establishment of a porcelain industry in the Hizen area, followed by the development of polychrome enamel techniques, brought an end to the long period of inactivity in the world of Japanese ceramics in general. Clearly the fact that the porcelain produced in western Hizen was closely connected with the local clan's economic policies underlay the overt part it played in national trade. I would like here to consider various factors affecting the marketing of Hizen porcelain throughout Southeast Asia and in such far-off places as Europe during the latter half of the seventeenth century.

It should be realized that the Nabeshima clan chose to develop its local porcelain industry as a means of fulfilling the economic policies of the fief under its control. Clan leaders began to promote porcelain as a trade item of not just local, but national consumer interest and expended considerable effort in levying production and transportation taxes. Moreover, from 1637, the Tokugawa government adopted an isolation policy that forbade foreign trade. The porcelain industry in Hizen was, however, favored by the fact that the central government decided to set up a special office in Nagasaki Dejima, which was situated close to Hizen, for the purpose of keeping one trade window open to the world. The Nabeshima clan was thus able to deal with the Dutch and Chinese at Nagasaki Dejima after 1640. Trading relations were further improved by the development of domestic shipping lines. This led to a number of wholesalers from various parts of Japan setting up offices in the port of Imari, from which Hizen porcelain was shipped to local destinations.

The Dutch East India Company was largely responsible for the dispersal of Hizen porcelain abroad. This company was then active in Southeast Asia, with the full authority of the Dutch government to support it in its economic dealings. The company set up bases at Batavia in Java and at Cape Town in South Africa before establishing trading relations with Japan. Moreover, the expanding porcelain trade in Hizen was further helped by the fact that China underwent

11

a period of some turmoil at the end of one and the beginning of another dynastic era between 1658 and 1682. The political situation was such that Chinese porcelain became extremely difficult to obtain. The Dutch East India Company thereupon found itself unable to meet the demand for porcelain from its European clients and was forced into buying Japanese products. Finally, the demand in Europe itself shifted during the seventeenth century from gold and silver to glass and ceramic articles, as the royal families of such countries as Holland, England, Germany, and France turned to the collection of china as a symbol of their status and power. These three factors contributed to the development of Japanese porcelain, which was favored by the state of affairs both at home and abroad and which resulted in the export of Hizen wares to a number of countries overseas.

Changes in the Porcelain Trade
As mentioned, the Dutch East India Company was the link between porcelain made by unknown craftsmen in provincial Hizen and an international porcelain market in Southeast Asia and Europe. The company was founded in 1602, organized as a government-backed trading company. It became an extremely profitable business, backed by a fleet of 150 trading vessels, 40 cargo ships, and a standing force of 10,000 men.

The Dutch trading post in Japan was first established at Hirado, before being moved at the Tokugawa shogunate's command to Nagasaki Dejima. From then on, for a period of approximately two and one-half centuries, from 1609 to 1863, friendly relations between Holland and Japan were maintained. According to extant records kept by the trading post, the first dealings in Japanese porcelain occurred in 1653, when 2,200 medicine pots were exported to meet an order by a pharmaceutical merchant in Batavia. These records, which are now in the Hague National Library, report that Hizen's fine-quality porcelain was first traded with regularity in 1660 and that the largest quantities of Japanese porcelain were shipped overseas between 1663 and 1672. According to these records, the main export trade occurred between 1653 and 1757. It then came to a halt, although a very small amount of sideline business in porcelain was conducted by members of the trading post.

The boom in the porcelain trade occurred in 1663–64. Most of the wares exported were cobalt blue decorated (*sometsuke*) medicine pots, plates, cups, lidded butter dishes, and incense burners, although it has also been recorded that very large lidded polychrome enameled jars used for burning incense were also traded.

From 1673 to 1687, one can see that Hizen porcelain began to be used in everyday life in the European home, for cups, oil jars, oil bottles, water bottles, and shallow bowls were bought and sold by the Dutch East India Company. From 1688 to 1703, a lot of large, decorative, enameled bowls and jars and other lidded pots were exported, along with oil and saké containers, lugged and rectangular bottles, small jars, and so on. A fairly large number of Kakiemon style wares were also traded. From about 1713, there was a considerable increase in orders for polychrome enameled wares.

In approximately 1697, the Arita Sarayama council system was functioning, and the senior town councillor, Takagi Hikoemon, was appointed by the Nabeshima authorities as the Officer in Charge of Porcelain Exports to China and Holland at Nagasaki Dejima. Four or more Dutch ships put into Dejima that year, loading up with cargoes of bowls, *choku* cups, jars, flower vases, and handled bottles.

Trade began to decline from about 1735, but recovered again between 1751 and 1763, although from 1759 large orders for porcelain decreased. One reason for this was the revival of the porcelain industry in China and the ability of the Dutch to purchase Chinese porcelain directly from Canton in South China. However, in 1715, the British East India Company was founded and started trading overseas. At this time also, porcelain factories were set up in Europe itself, and these fulfilled the demand for porcelain by producing wares in Oriental styles.

An Appraisal
The earliest cobalt underglaze decorated Arita wares, made by the first kilns in Uchiyama, strongly capture the flavor of the Momoyama period. All the early works—the *sometsuke* saké cups with their autumn leaf motifs; bowls with floral scroll patterns; plates and dishes with grape and vine designs—were made by Korean craftsmen who were brought to Japan from their own country. Their struggles in a new country, immersed in the intricacies of clay and fire, are expressed in the deep cobalt blue decorations of dishes and in the melancholy of the pine and plum motifs on narrow-necked bottles.

Once the Edo period began in the early seventeenth century, things took a turn for the better. Ships, sailing under the flag of the Dutch East India Company, began putting into Nagasaki Dejima, and Imari wares started to rival Chinese porcelain exported along the "Ceramic Road," from Southeast Asia across the Indian Ocean to Cape Town in South Africa, and thence to Amsterdam. Large overglaze enameled jars and plates began to decorate the palaces of Europe—Versailles, Hampton Court, and Shönbrunn. Thanks to the part played by the Dutch East India Company, Imari wares did not just decorate the inside of European houses; they were used at the lavish receptions held in the baroque and rococo castles and courts. The wave of popularity with which Imari ware was met finally led to the establishment of porcelain kilns in Europe. These for the most part imitated the porcelain made in Japan, so that the Imari style finally led to fruitful contact between East and West.

In the late Edo period (late eighteenth to mid-nineteenth centuries), local demand in Japan for Imari porcelain increased considerably. Vessels used for transporting rice to and from wholesalers located all over Japan would put into the port of Imari in western Hizen and would load up with Imari wares, which were then distributed not just to the courtiers and military upper classes living in Edo, Kyoto, and Naniwa, but to merchants, townsmen, and ordinary people living in the cities. Thus, everyone came to know about Imari porcelain, although the "presentation" wares were prized solely by members of the nobility, the shogun's household, and various clan lords.

It was in the late Edo period that Imari wares came to be used in inns, farmhouse kitchens, and shops all over the country. This was mainly due to the perfection at this time of the land and sea distribution system. In particular, there was hardly a single house that did not own an Imari oil lamp—either a cobalt blue underglazed piece with plum, pine, or bamboo grass motif, or a polychrome enameled piece with a floral design. Late Edo Imari was further characterized by the *choku* noodle cup, which was an essential item on every domestic table. These two types of pot, with their artlessly manufactured, typical Imari type of beauty, were designed in a variety of forms and styles, weaving into the Edo citizen's heart a deep feeling for function and beauty. Thus, Old Imari combines various formal aspects of Edo period taste with the spread of popular culture and continues to this day to be an essential part of the unique world of Japanese porcelain.

Site of the old kiln at Tengudani.

Izumiyama quarry for porcelain stone.

Kilns at Arita.

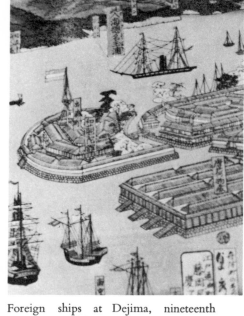

Foreign ships at Dejima, nineteenth century woodblock print.

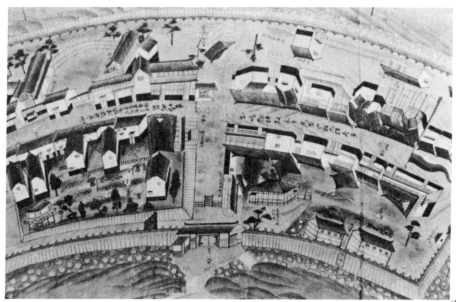

Dejima at Nagasaki, the only port opened to overseas trade (limited to Holland and China) during the Edo period.

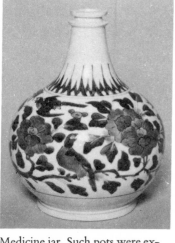

Medicine jar. Such pots were exported to Southeast Asia by the Dutch East India Company.

Imari pots were used to punctuate the interior design of Vienna's Schönbrunn Palace.

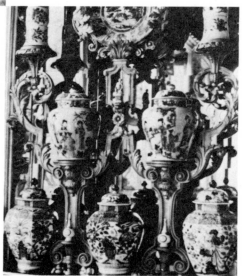

The opulent baroque interior of Charlottenburg Palace in Berlin also displays Imari ware.

Kilns of Arita Sarayama

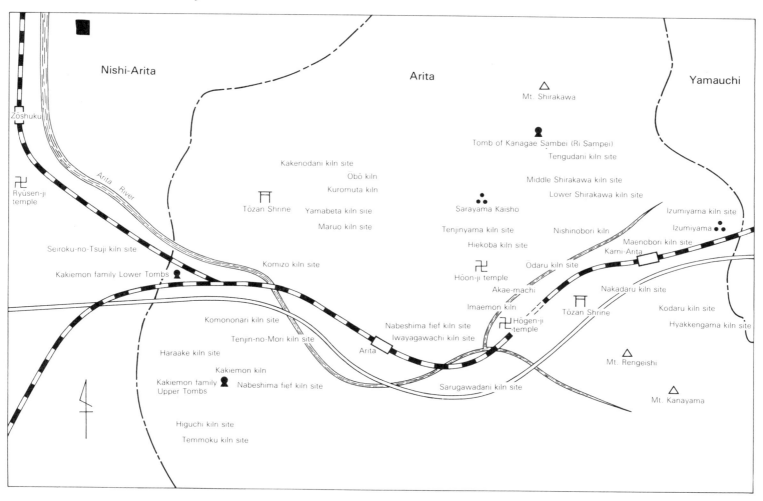

Nishi-Arita

Arita

Yamauchi

△
Mt. Shirakawa

Zōshuku

Tomb of Kanagae Sambei (Ri Sampei)
Tengudani kiln site

Arita River

Kakenodani kiln site

卍
Ryūsen-ji temple

Obō kiln

Middle Shirakawa kiln site

Kuromuta kiln

Lower Shirakawa kiln site

Izumiyama kiln site

Tōzan Shrine

Yamabeta kiln site

Sarayama Kaisho

Izumiyama

Maruo kiln site

Tenjinyama kiln site

Nishinobori kiln

Seiroku-no-Tsuji kiln site

Hiekoba kiln site

Maenobori kiln site
Kami-Arita

Kakiemon family Lower Tombs

Komizo kiln site

卍
Hōon-ji temple

Odaru kiln site

Akae-machi

Nakadaru kiln site

Komononari kiln site

Imaemon kiln

卍 Hōgen-ji temple

鳥 Tōzan Shrine

Kodaru kiln site

Tenjin-no-Mori kiln site

Nabeshima fief kiln site

Hyakkengama kiln site

Haraake kiln site

Iwayagawachi kiln site

Arita

Kakiemon kiln

△
Mt. Rengeishi

Kakiemon family Upper Tombs

Nabeshima fief kiln site

Sarugawadani kiln site

△
Mt. Kanayama

Higuchi kiln site

Temmoku kiln site

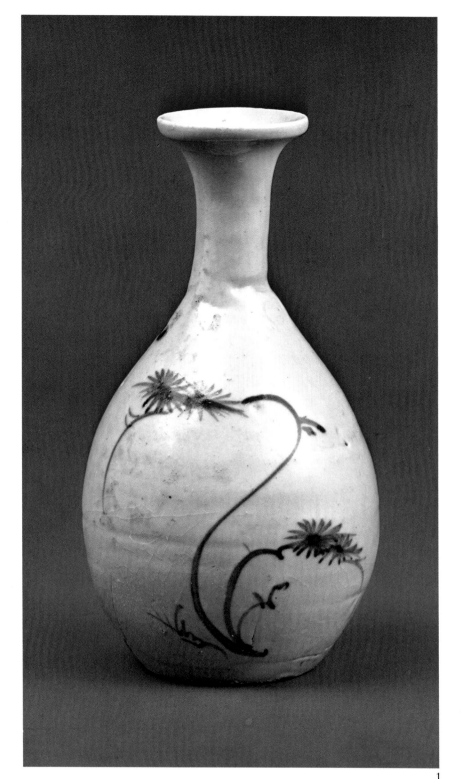

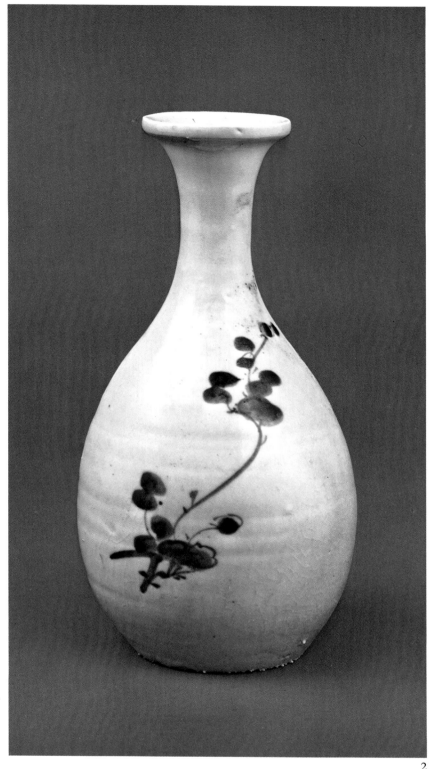

1

2

*1, 2. Cobalt underglaze decorated bottles, plum and pine designs. Plate 1,
H. 22.0 cm.; Plate 2, H. 21.7 cm. Arita Ceramics Museum.*

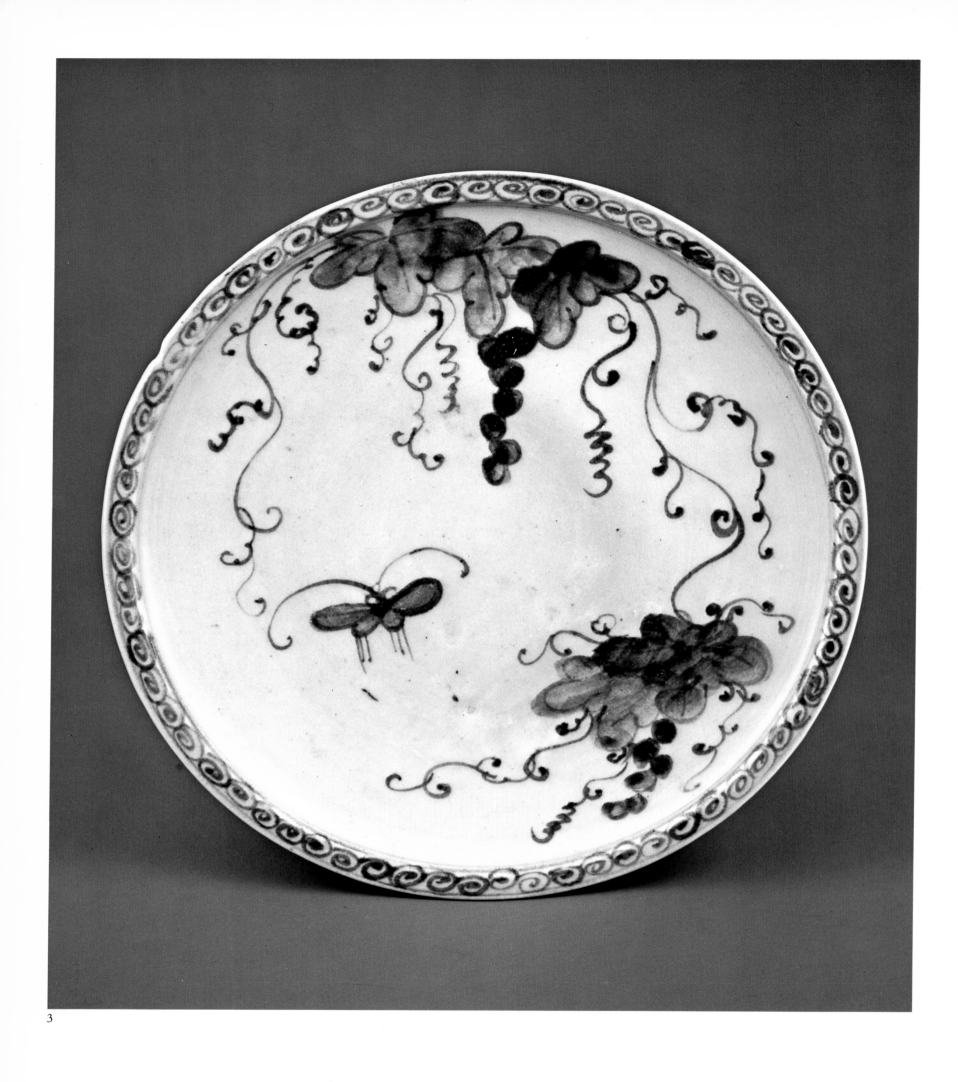

3

3. *Cobalt underglaze decorated dish, grapevine and butterfly designs. D.*
18.8 cm. Saga Prefectural Museum.

18

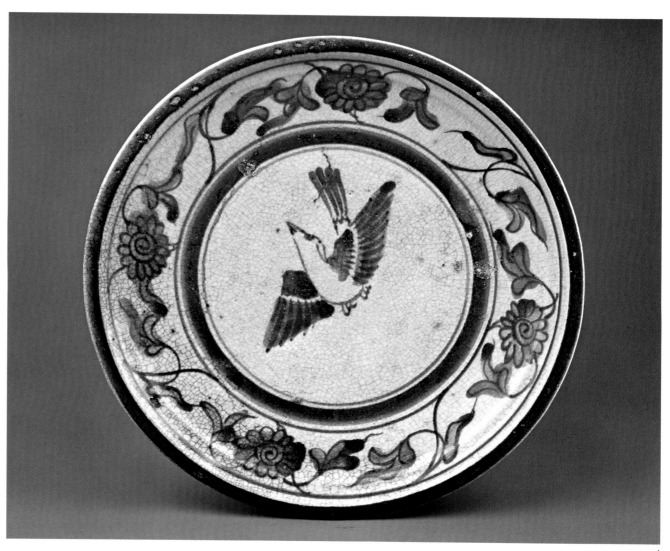

4

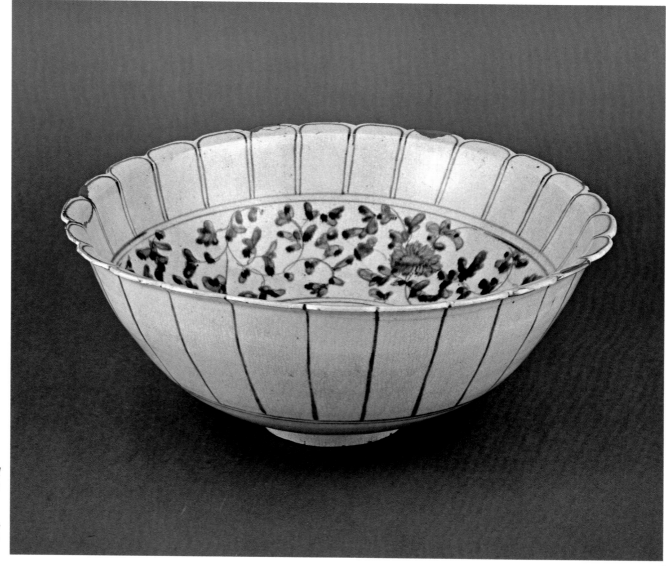

4. Cobalt underglaze decorated plate, bird
and chrysanthemum scroll design. D. 21.3
cm.

5. Cobalt underglaze decorated foliate bowl,
floral scroll design. D. 33.5 cm. Idemitsu
Museum of Art.

5

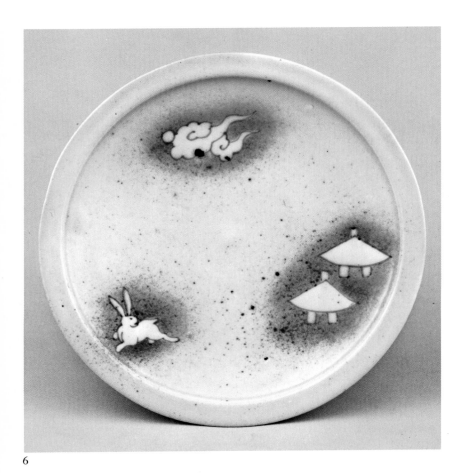

6

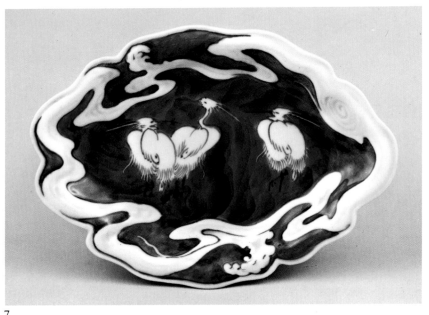

7

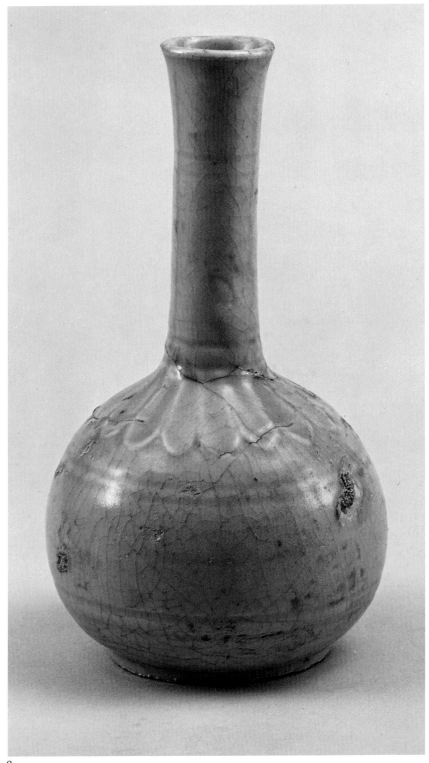

8

6. *Cobalt underglaze decorated dish, rabbit design in spray glaze* (fuki-
zumide). *D. 19.3 cm. Imaemon Antique Ceramics Center.*

7. *Azure-glazed dish, white heron design. 17.0 × 12.2 cm. Kamochi
Collection.*

8. *Celadon bottle, incised floral design. H. 20.2 cm. Arita Ceramics
Museum.*

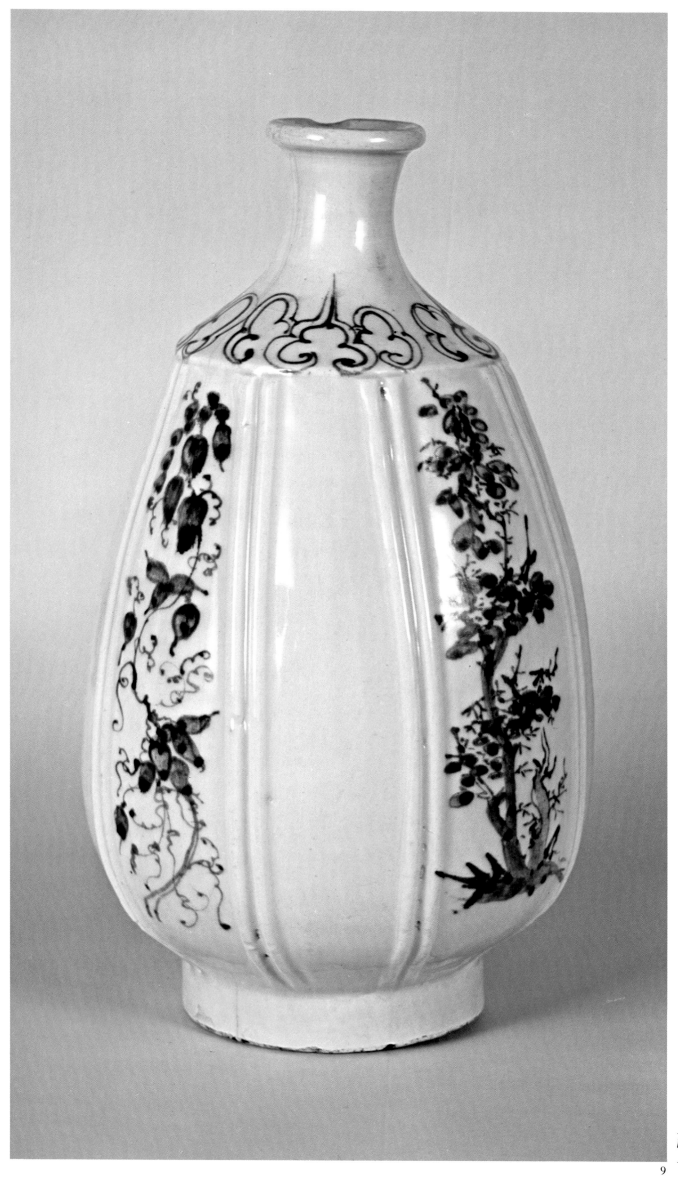

9. *Cobalt underglaze decorated, fluted bottle, floral designs in panels. H. 31.5 cm. MOA Museum of Art.*

9

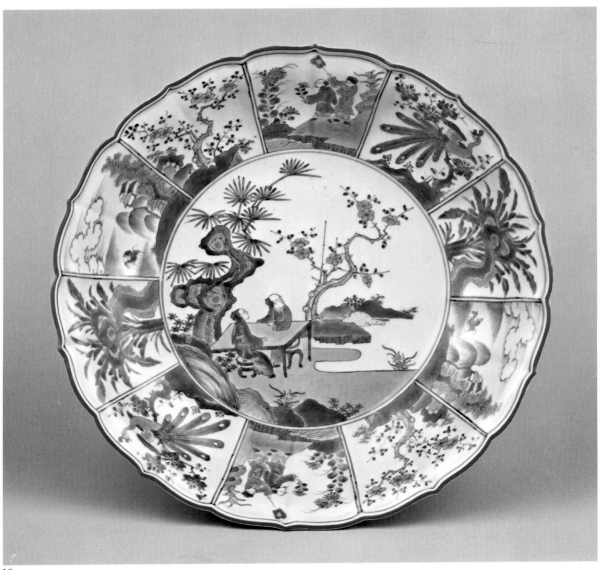

10

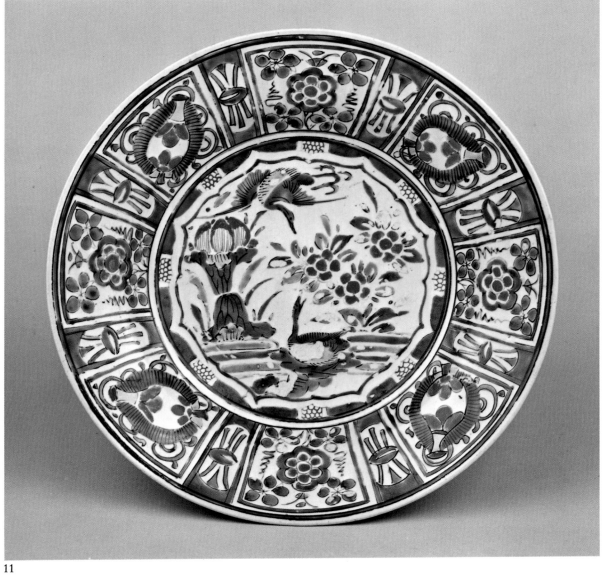

11

10. *Cobalt underglaze decorated foliate dish, flower, bird, and Chinese literati designs. D. 38.0 cm. Kamochi Collection.*

11. *Polychrome enameled flat dish, bird-and-flower designs. D. 31.1 cm. Kurita Art Museum.*

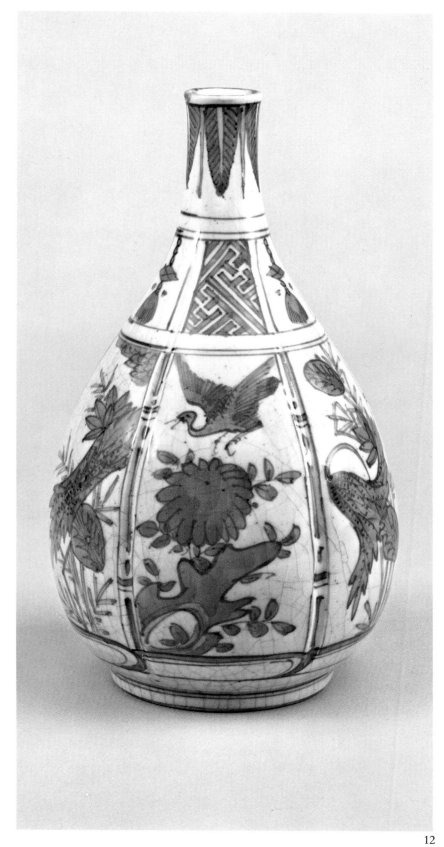

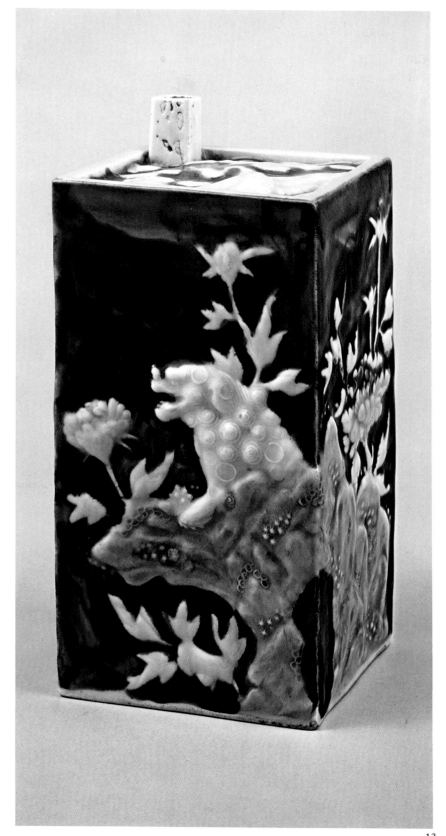

12

13

12. *Cobalt underglaze decorated hexagonal bottle, bird-and-flower designs in panels. H. 27.5 cm. Idemitsu Museum of Art.*

13. *Azure-glazed square bottle, rock, peony, and Chinese lion relief design. H. 20.3 cm.*

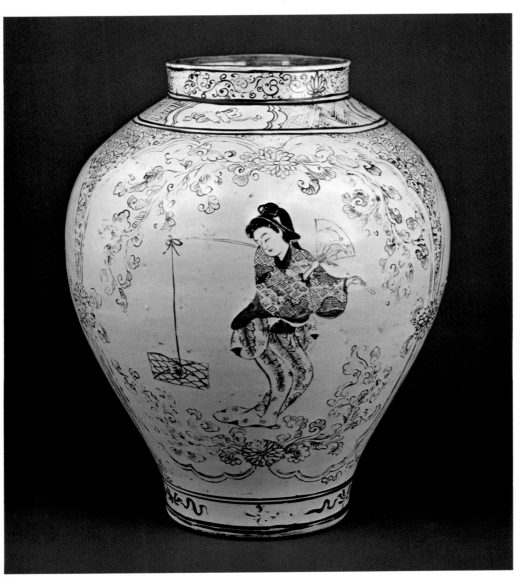

14

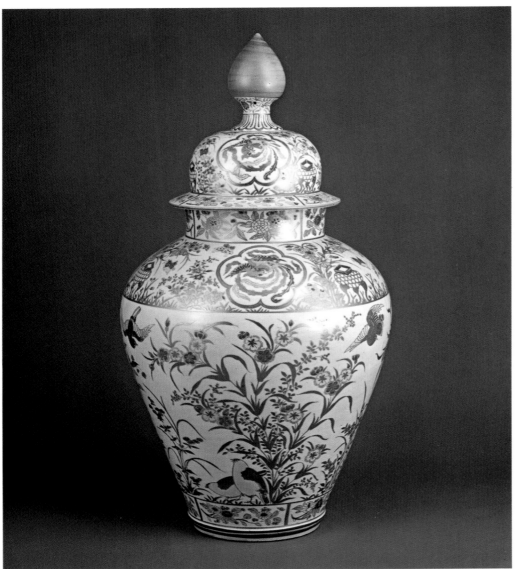

14. *Large overglaze enameled vase, design in three panels of popular customs. H. 38.5 cm. Tanakamaru Collection.*

15. *Large two-toned overglaze enameled vase, bird-and flower-design. H. 60.5 cm. Kamochi Collection.*

15

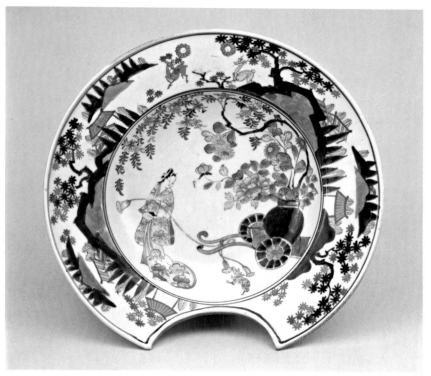

16

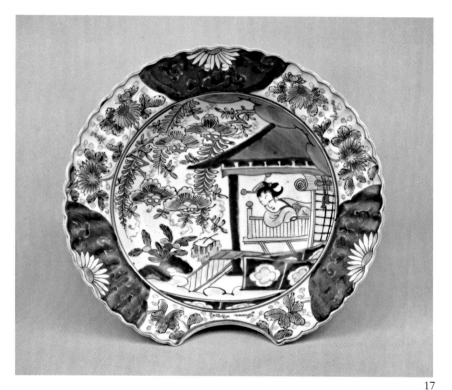

17

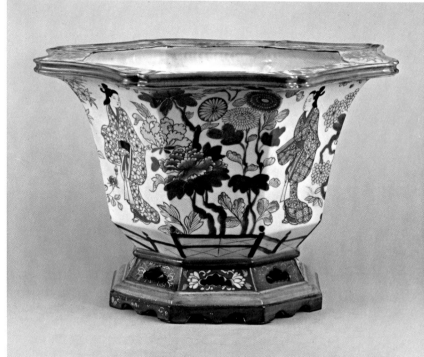

19

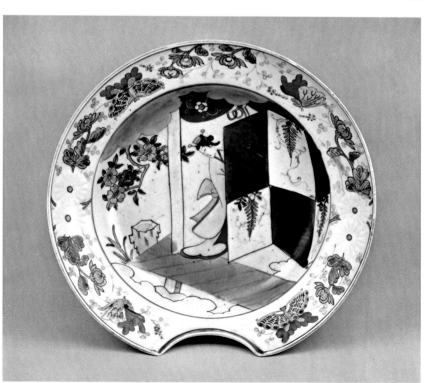

18

16. *Polychrome enameled shaving dish, genre design. D. 28.1 cm. Saga Prefectural Museum.*

17. *Polychrome enameled shaving dish, genre design. D. 27.6 cm. Kurita Art Museum.*

18. *Polychrome enameled shaving dish, genre design. D. 30.6 cm. Tanaka-maru Collection.*

19. *Polychrome enameled vessel, chrysanthemum, peony, and genre design. H. 27.0 cm. Kambara Collection, Arita Historical Museum.*

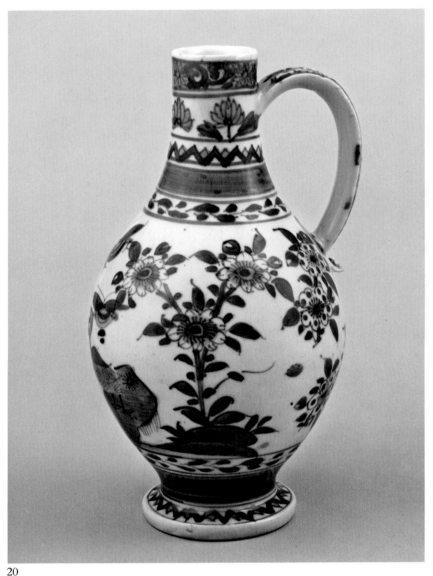

20

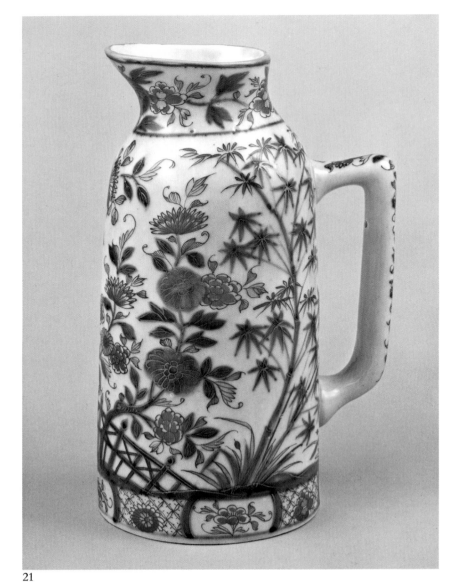

21

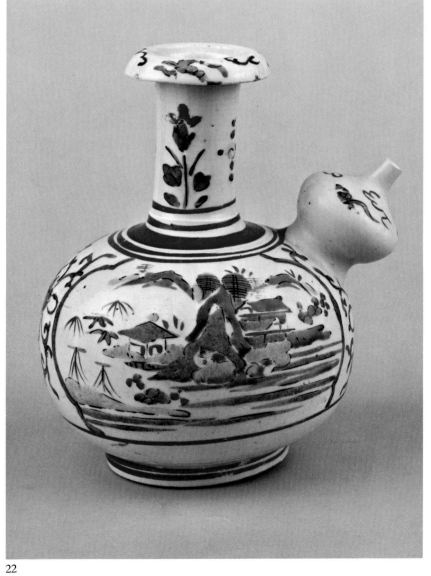

22

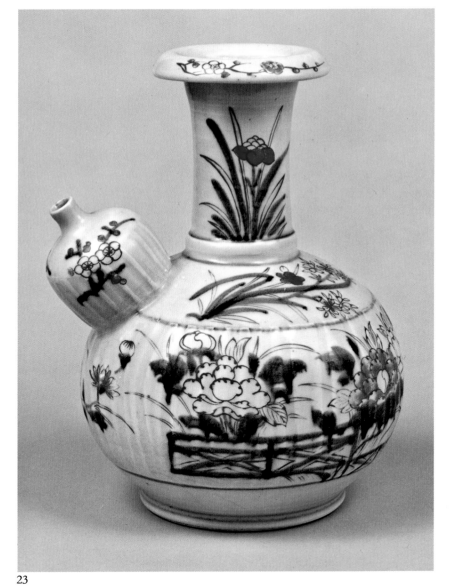

23

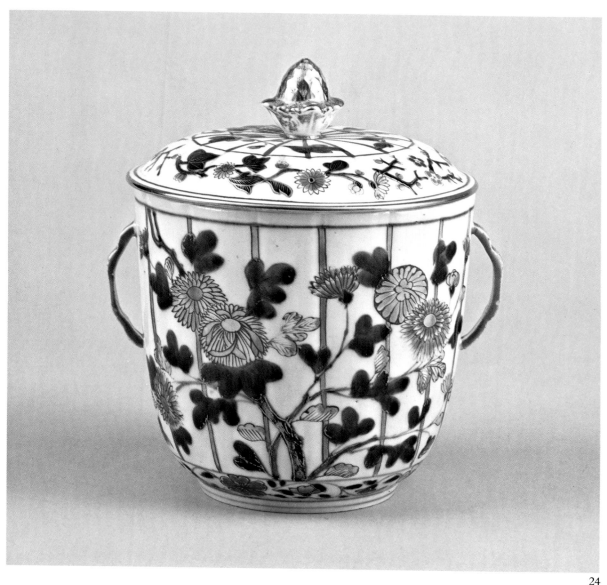

24

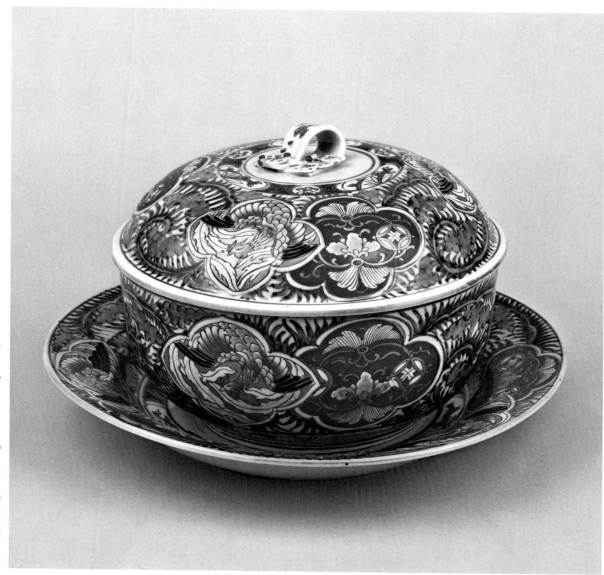

20. *Cobalt underglaze decorated jug, floral design. H. 23.0 cm. Kamochi Collection.*

21. *Polychrome enameled jug, bamboo, grass, and flower design. H. 24.0 cm. Kamochi Collection.*

22. *Polychrome enameled ewer, landscape design. H. 20.8 cm. Imaemon Antique Ceramics Center.*

23. *Polychrome enameled ewer, floral design. H. 21.0 cm. Kurita Art Museum.*

24. *Polychrome enameled, handled and lidded container, chrysanthemum design. H. 17.5 cm. Arita Ceramics Museum.*

25. *Polychrome enameled lidded bowl and saucer, flower and bird design. H. 21.0 cm.; Saucer, D. 33.3 cm. Kambara Collection, Arita Historical Museum.*

25

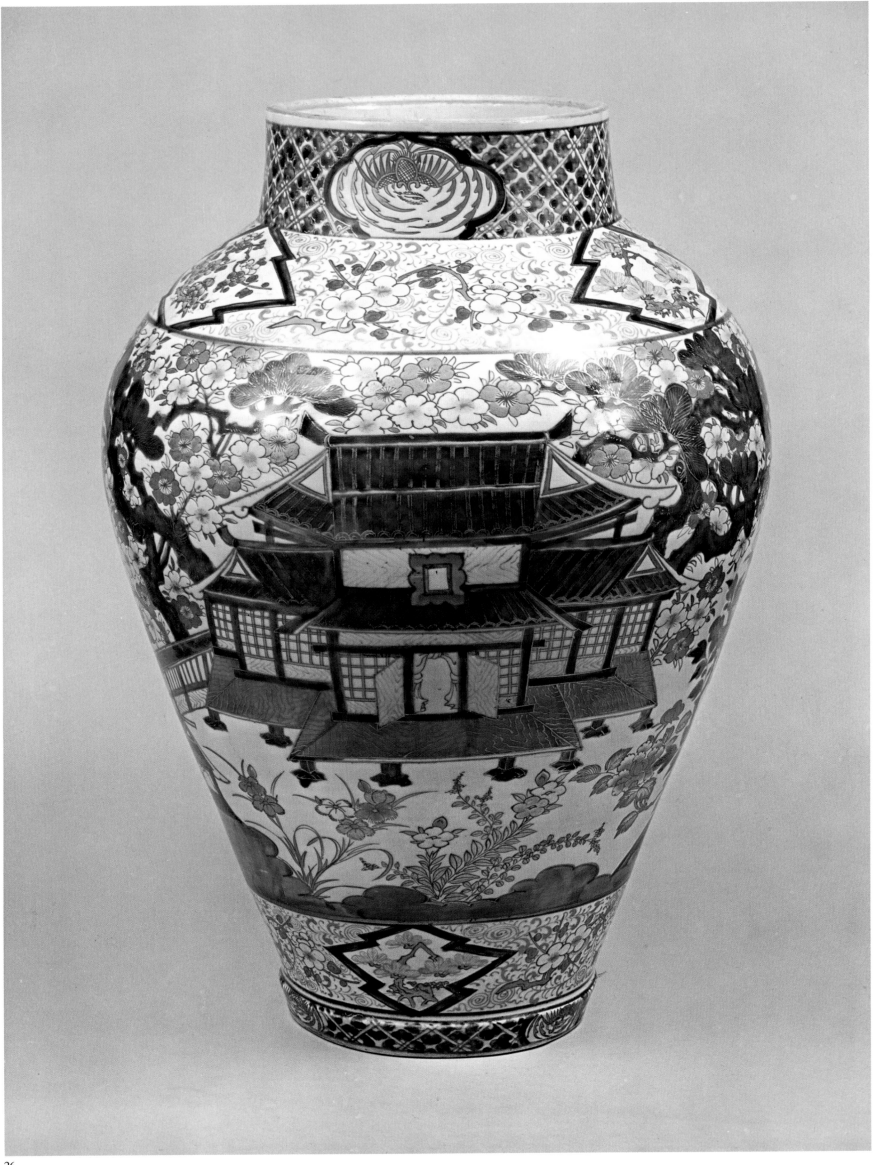

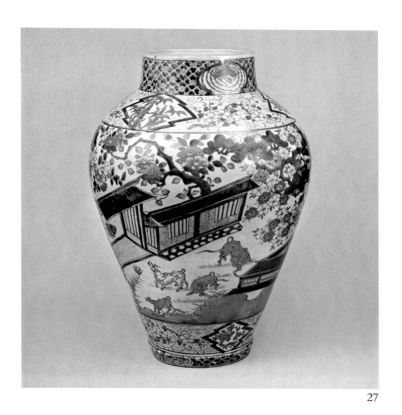

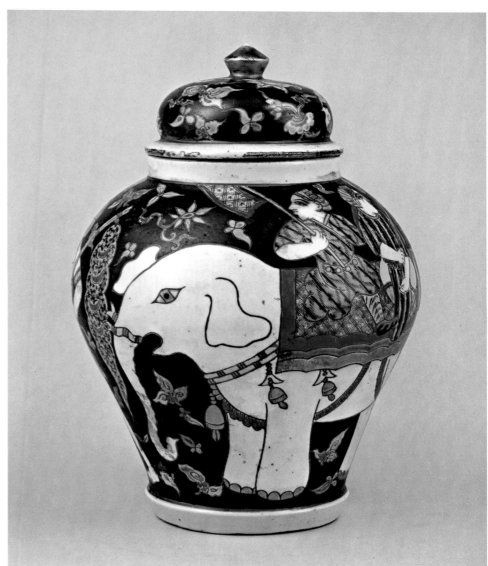

27

28

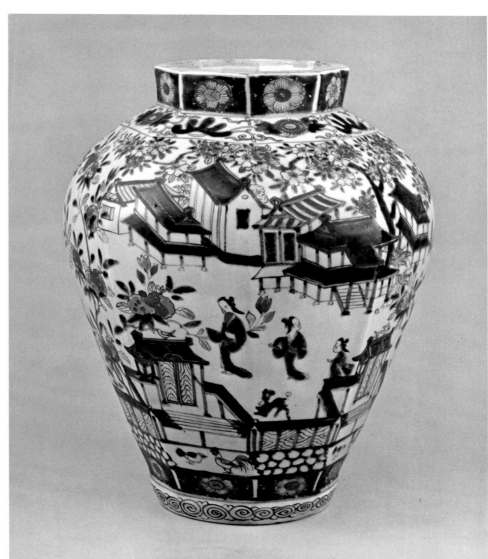

26, 27. Large polychrome enameled jar, Dazaifu design. H. 59.7 cm. Genemon Pottery Center.

28. Polychrome enameled lidded jar, "Southern Barbarian" (namban) design. H. 24.0 cm. Kobe Municipal Museum of Namban Art.

29. Polychrome enameled faceted jar, genre design. H. 35.0 cm.

29

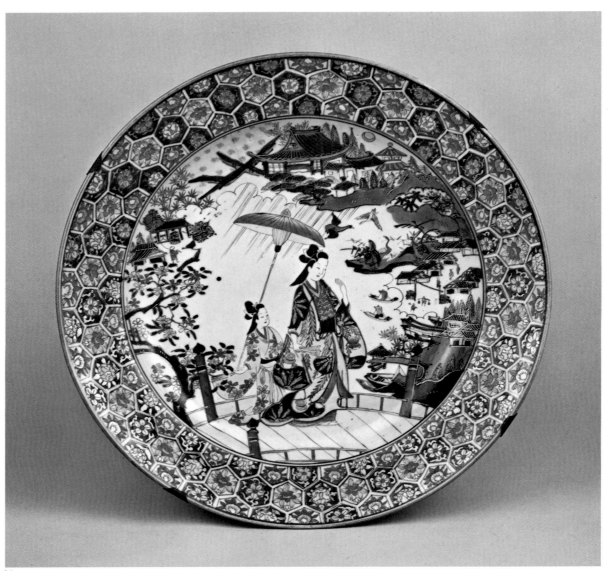

30

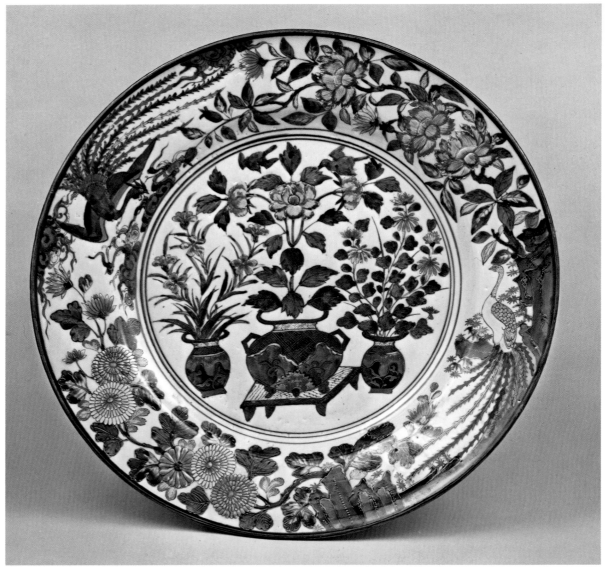

30. Large polychrome enameled dish, courtesan and "Eight Views of Ōmi" design. D. 41.5 cm. Kambara Collection, Arita Historical Museum.

31. Large polychrome enameled flat dish, basket of flowers and bird design. H. 54.8 cm. Kambara Collection, Arita Historical Museum.

31

30

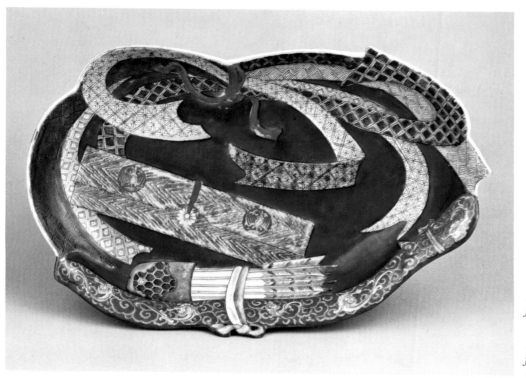

32

32. Polychrome enameled irregular dish, festoon (noshi) and arrow design. 30.5 × 19.4 cm. Tanakamaru Collection.

33. Large polychrome enameled lidded jar, flower-and-bird design. H. 47.0 cm. Kurita Art Museum.

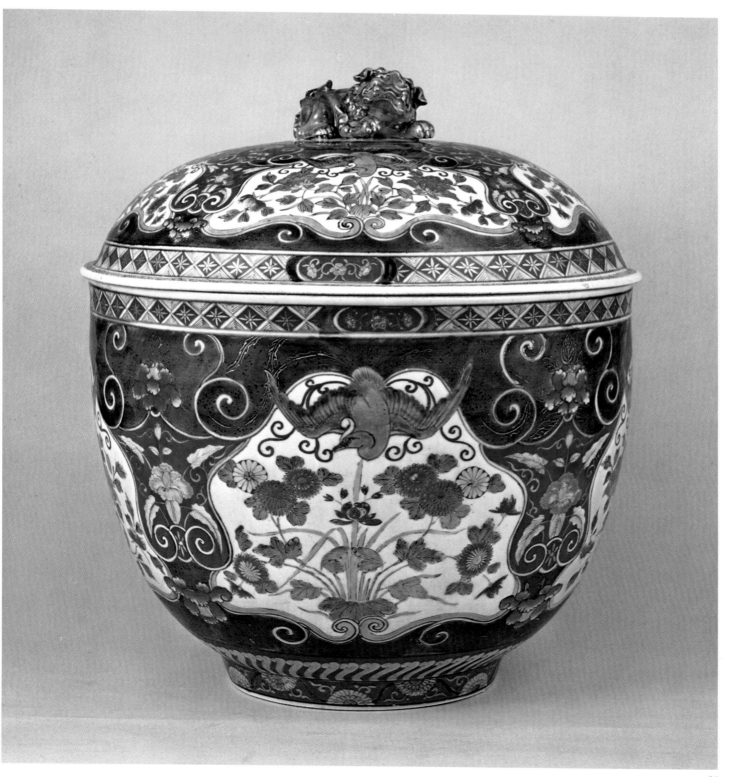

33

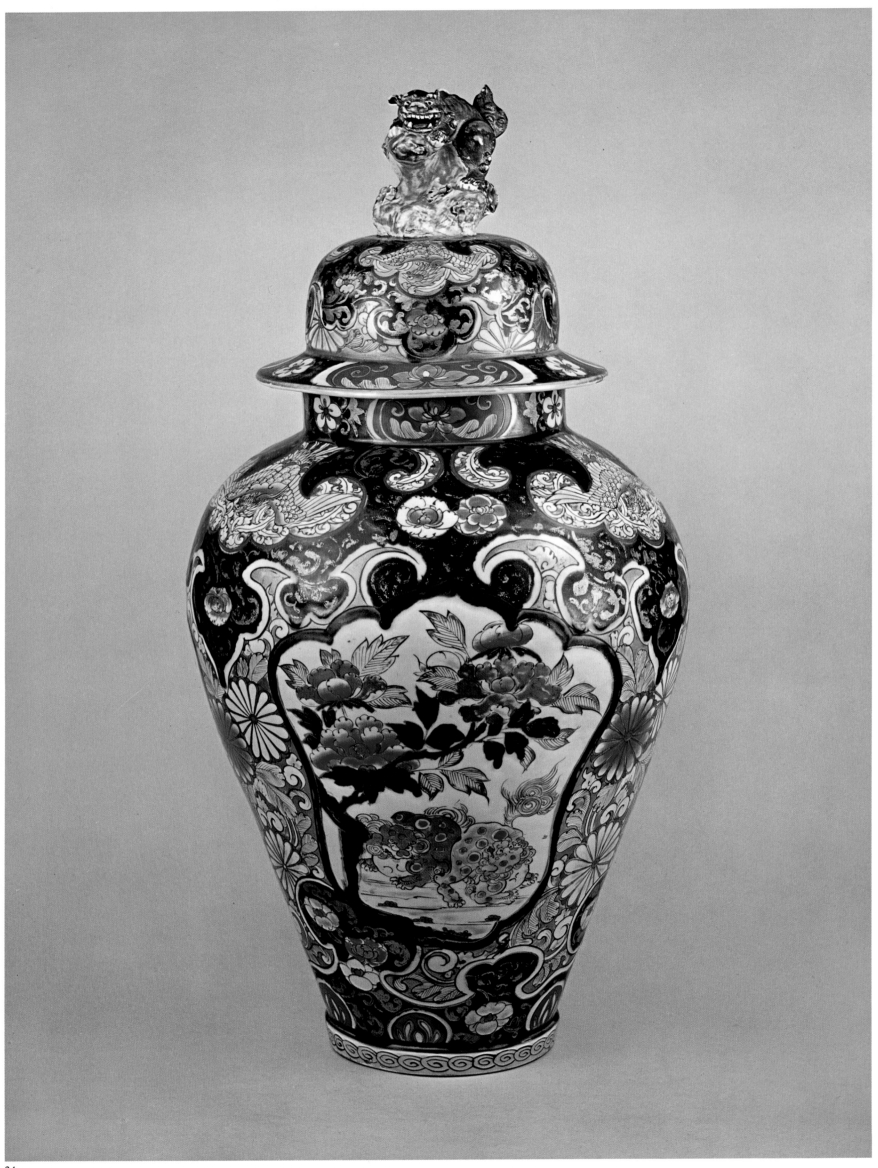

34. *Large polychrome enameled vase, peony, Chinese lion, and sacred bird design. H. 82.0 cm. Kambara Collection, Artia Historical Museum.*

35. *Polychrome enameled lampstands, flower and basket designs. Left, H. 59.0 cm. Kambara Collection, Arita Historical Museum.*

36. *Polychrome enameled bowl, "five ships" design. D. 36.4 cm. MOA Museum of Art.*

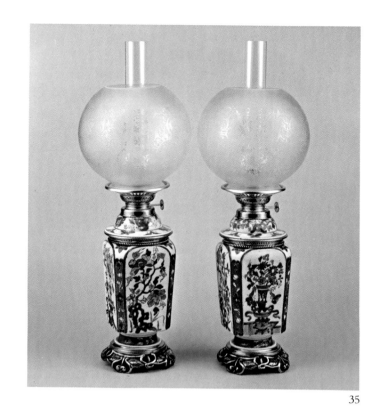

35

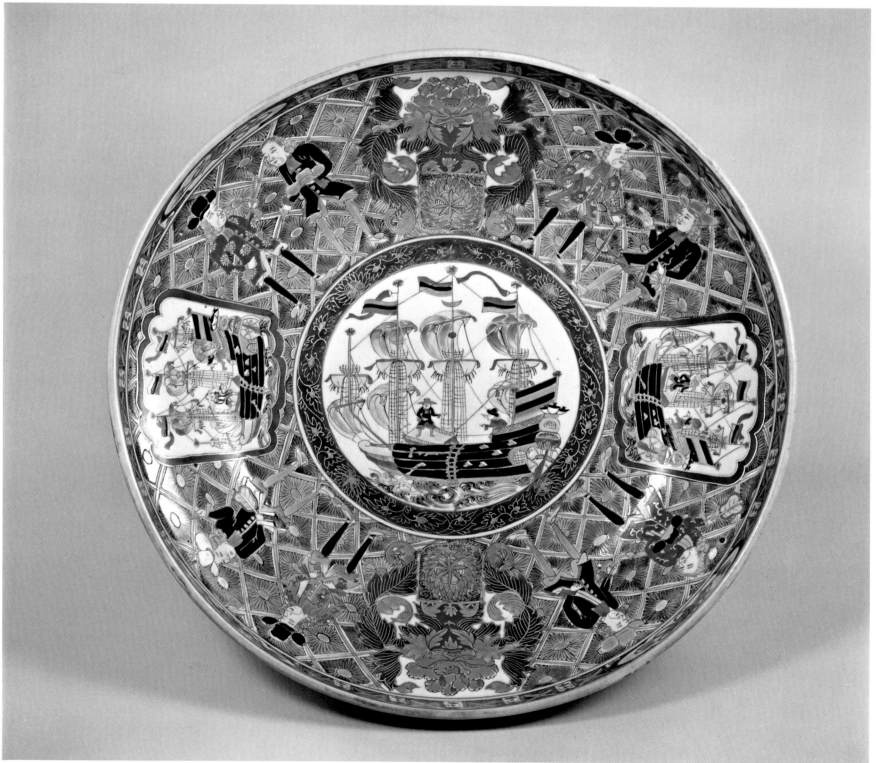

36

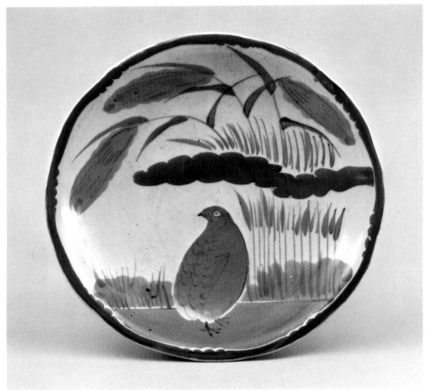

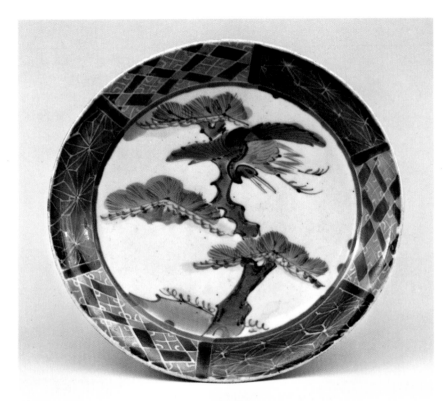

37

38

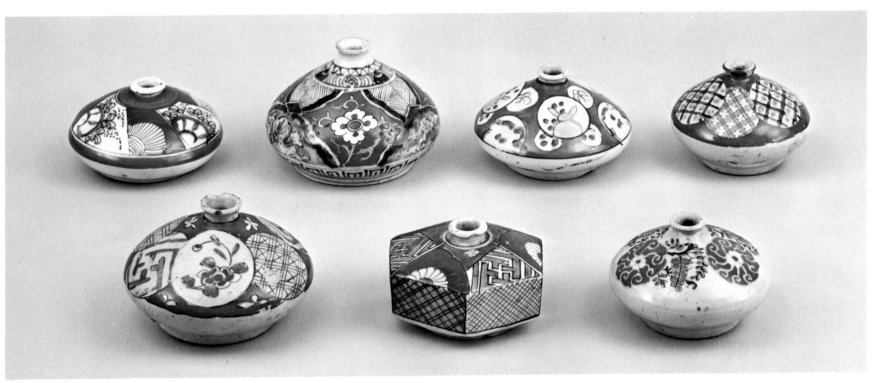

39

37. *Cobalt underglaze decorated bowl, foxtail millet and quail design. D. 20.8 cm.*

38. *Cobalt underglaze decorated plate, pine tree and crane design. D. 22.3 cm.*

39. *Polychrome enameled oil jars. Back row: left, H. 5.0 cm., D. 9.1 cm.; front row: left, H. 6.2 cm., D. 9.6 cm.*

34

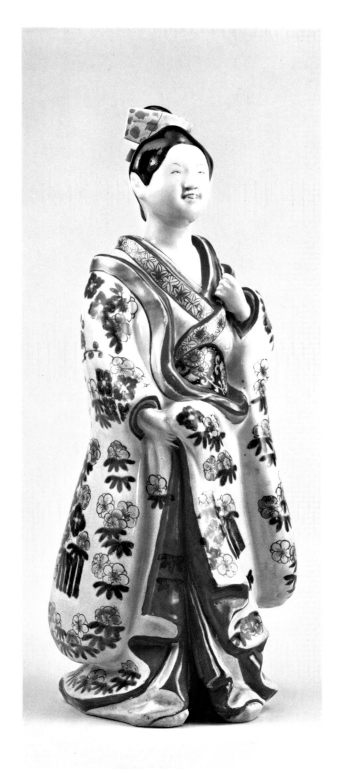

40

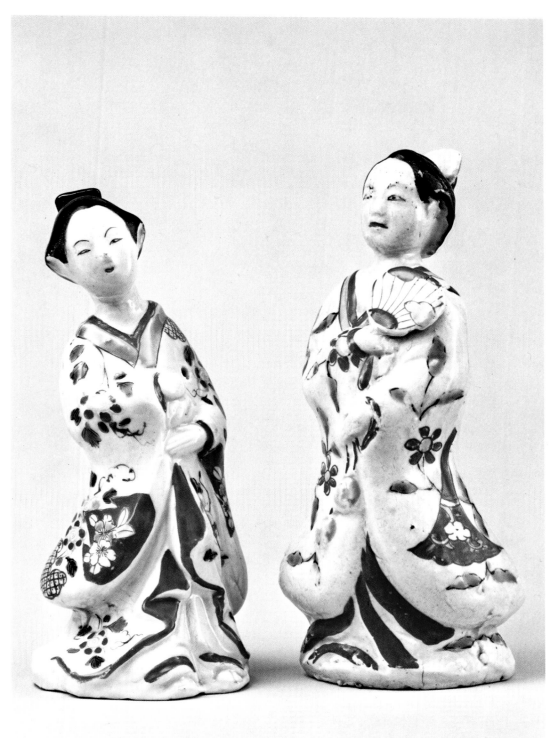

41

40. *Polychrome enameled figurine. H. 46.5 cm.*

41. *Pair of polychrome enameled figurines. Left, H. 18.0 cm. Kambara Collection, Arita Historical Museum.*

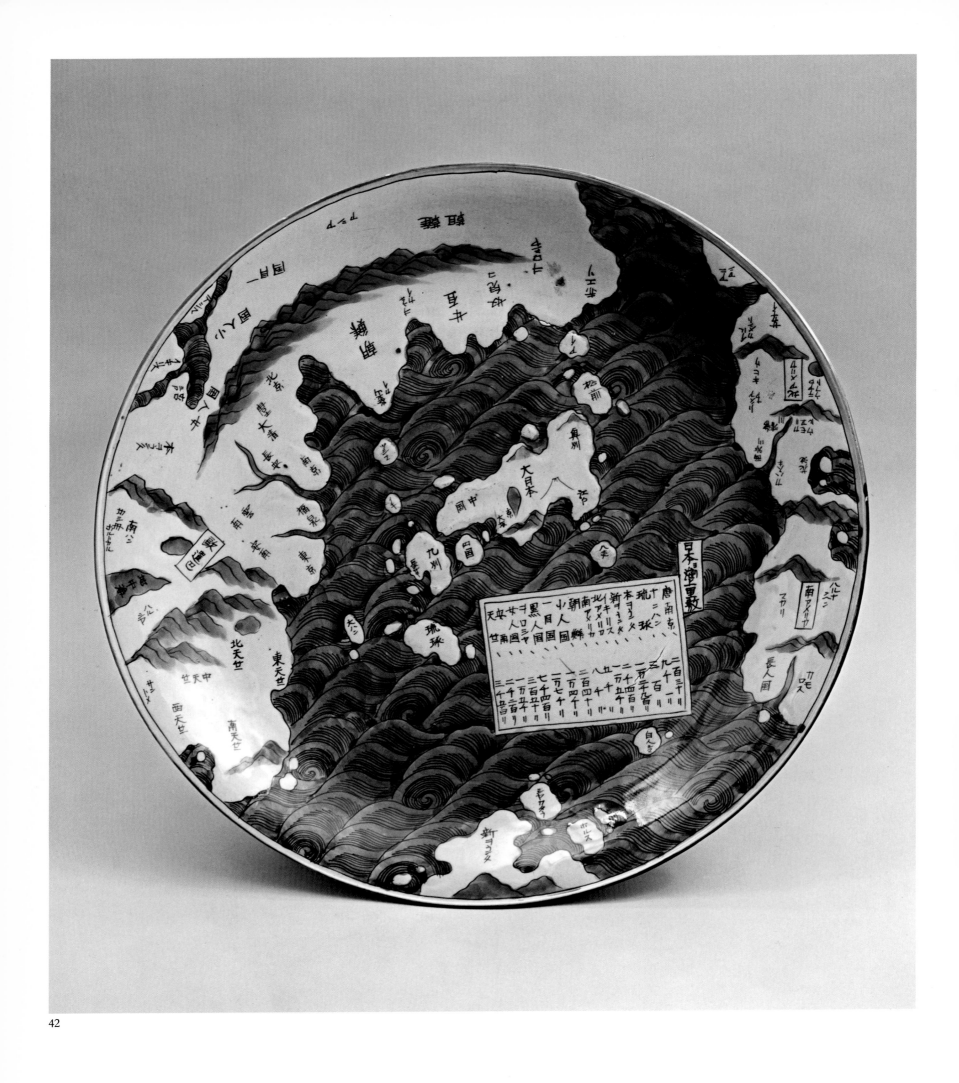

42. Large cobalt underglaze decorated plate, map of East Asia. D. 52.1 cm. Saga Prefectural Museum.

Plate Notes

1, 2. *Cobalt underglaze decorated bottles, plum and pine designs. Plate 1, H. 22.0 cm.; Plate 2, H. 21.7 cm. Arita Ceramics Museum.*

These two precious examples of Arita porcelain were made at the very dawning of porcelain production in Japan. The bottles were unearthed in the lowest stratum of the kiln sites of Kamishirakawa and Tengudani at Arita Uchiyama. What is remarkable is the fact that research shows them to have been fired at least as early as 1605. The glaze is bluish white and has not been fired to maturing temperature, while the underglaze cobalt is slightly dull. These points show just how early in porcelain production these pots were made.

3. *Cobalt underglaze decorated dish, grapevine and butterfly designs. D. 18.8 cm. Saga Prefectural Museum.*

This dish is reminiscent of mid-Yi dynasty cobalt decorated porcelain. The mood of its indigo touches and the sense of nostalgia in the weeping trails of the vines and butterfly brushwork are quite marvelous. The *dami* style of cobalt underglazing is typical of early Arita ware. The porcelain clay body is slightly bluish. The flat dish is stable and it was possibly fired at the old Arita Uchiyama area Hiekoba kiln. It gives off an air of having been made by Korean potters living in Japan and working far away from their home country.

4. *Cobalt underglaze decorated plate, bird and chrysanthemum scroll design. D. 21.3 cm.*

Here we have a dynamically painted sparrow, while the edge of the plate has been decorated with a flowing chrysanthemum scroll. The contrast of light and dark in the cobalt pigment is magnificent, while the glaze itself is tinted slightly blue and has crazed. Recently, a number of fragments, similar in both style and design, have been unearthed at the Hyakkengama kiln. This would indicate that in all probability this pot was fired at the same kiln, which flourished during the early period of Imari ware production.

5. *Cobalt underglaze decorated foliate bowl, floral scroll design. D. 33.5 cm. Idemitsu Museum of Art.*

Large bowls are rare among early Imari wares. This one, with its foliate rim, is unwarped and has been modeled with great feeling. There are slight traces of blue in the glaze. There is a beautiful flow in the lines of the floral scroll, and the brushwork is superlative. This piece would appear to have come from the Hyakkengama kiln.

6. *Cobalt underglaze decorated dish, rabbit design in spray glaze (fuki-zumide). D. 19.3 cm. Imaemon Antique Ceramics Center.*

In the East, the design of a rabbit leaping across a dark, moonlit night used to be a congratulatory motif. The design has been done by the spray method of glazing, which appears on everyday wares made in China during the Ming dynasty, and the flat dish is characterized by a very narrow foot rim. The dish was fired in the old kiln of Hiekoba in Arita Uchiyama, and a large number of shards of this type of work have been unearthed there

7. *Azure-glazed dish, white heron design. 17.0 × 12.2 cm. Kamochi Collection.*

This piece has been passed down through the centuries, and its history can be gauged by comparing the dish with similar looking shards unearthed at the old kiln site of Ōdaru in Arita Uchiyama. It is an unusual, irregularly shaped dish, press molded and decorated with marbled cobalt effects.

8. *Celadon bottle, incised floral design. H. 20.2 cm. Arita Ceramics Museum.*

This bottle is typical of the earliest period of porcelain production in Japan, and there still lingers about its celadon glaze an air of the celadon pots made in Korea's Koryŏ dynasty. This long-necked (*tsurukubi*) bottle was unearthed in the lowest stratum on the site of the defunct kilns of Tengudani. Its chrysanthemum design was incised with a bamboo carving tool.

9. *Cobalt underglaze decorated, fluted bottle, floral designs in panels. H. 31.5 cm. MOA Museum of Art.*

This piece is believed to stem from the Hyakkengama kiln, one of a group of kilns in the north of Takeo. It was probably fired around the end of the Genna era (ca. 1620), which was when early Imari wares were gradually shifting from simple Korean style designs to slightly more complex Chinese style cobalt underglaze decorated porcelain. Shards resembling the lip and body of this bottle have been unearthed from the old kiln site, while the slightly bluish tinge of the porcelain body is typical of Early Imari ware.

10. *Cobalt underglaze decorated foliate dish, flower, bird, and Chinese literati designs. D. 38.0 cm. Kamochi Collection.*

The style of decoration known as *fuyōde* was used by Ming dynasty Chinese potters and was adopted around the early

to mid-Edo period by Japanese potters before being adapted to suit local taste. The central part of this dish has a design consisting of water, mountains, and Chinese figures, while the foliate edge has been divided into ten sections, each being somewhat ornamentally decorated with flower-and-bird, Chinese figures, or tree designs. There is, nevertheless, great freshness in the marvelous suggestiveness of the indigo cobalt.

11. *Polychrome enameled flat dish, bird-and-flower designs. D. 31.1 cm. Kurita Art Museum.*

The *fuyōde* decoration style was the first of various types of Chinese Ming dynasty styles to gain a stable footing in Hizen porcelain production. Indeed, almost all the Early Imari export wares were *fuyōde* style patterns. This is a particularly fine example of the overglaze enameled wares of the Jōō and Kambun eras (1652–73), when Japanese porcelain production attained maturity and stability.

12. *Cobalt underglaze decorated hexagonal bottle, bird-and-flower designs in panels. H. 27.5 cm. Idemitsu Museum of Art.*

This piece would seem to have been fired at or near the Ōdaru kiln of Arita Uchiyama around the end of the Kan'ei era (1640), when cobalt underglaze decorated Arita pots were shifting in style from Korean Yi dynasty to Chinese Ming dynasty style. Bird-and-flower motifs are painted in panels to harmonize with the faceted form of the bottle.

13. *Azure-glazed square bottle, rock, peony, and Chinese lion relief design. H. 20.3 cm.*

It would seem as though press-molded bottles were occasionally made at the old kiln of Hiekoba in Arita Uchiyama, for shards similar to this bottle have been unearthed at this kiln site. There is considerable ingenuity and artistry in the blue porcelain relief of the peony and lion motif. This bottle is probably one of a pair made during the early Edo period and was used as a saké bottle by travelers.

14. *Large overglaze enameled vase, design in three panels of popular customs. H. 38.5 cm. Tanakamaru Collection.*

This vase has been divided into three "window" panels by means of a blackened silver chrysanthemum scroll. In each of these "windows," an early Edo period dancing girl has been painted in reddish black with occasional dashes of red to give variety to the design. This full-bodied vase is unfinished and is probably an experimental piece, although a smaller one like the one shown here may be found in the Amsterdam Museum of Art.

15. *Large two-toned overglaze enameled vase, bird-and-flower design. H. 60.5 cm. Kamochi Collection.*

This large vase has just red and gold overglaze enamels. This kind of contrast in color tones is extremely rare among such enameled vases. There is considerable vitality in the composition, with its overall floral design of asters and pinks together with the occasional wild bird, while the shoulder and lid of the vase have been given rather more ornamental flower-and-bird designs.

SHAVING DISHES

One of the more typical examples of unusual shaped pots found during the peak period of Old Imari production (around the time of the Genroku era) is that of the shaving dish. It is said that such saucers were used as hanging signs by barbers in Europe. String was passed through the two holes at the top of the dish, and the cutaway section was placed under the customer's chin before shaving. Still, these dishes would seem to have been more decorative than functional, for a lot of them have been painted with designs of *ukiyo-e* woodblock print type of women, together with typical Oriental bird-and-flower motifs.

16. *Polychrome enameled shaving dish, genre design. D. 28.1 cm. Saga Prefectural Museum.*

Fairly honest designs are to be found among those shaving dishes that have been handed down to us. This design is in the popular genre; the center shows a cart on which has been placed a basket full of spring and autumn flowers. One end of the harness rope is held by a woman in kimono. The border has been painted with autumn leaves and deer in two symmetrical sections and is replete with charm.

17. *Polychrome enameled shaving dish, genre design. D. 27.6 cm. Kurita Art Museum.*

This is a typical example of Old Imari export ware. A Nagasaki courtesan looks down from a raised reception room within the Maruyama entertainment district; her face is rather large, thereby giving her a somewhat coquettish appearance. Overall, the saucer combines good decorative techniques with elaborate brushwork.

18. *Polychrome enameled shaving dish, genre design. D. 30.6 cm. Tanakamaru Collection.*

The design here is given a sense of perspective by the way in which the girl appears to be moving away behind the screen. The brushwork is not elaborate, but rather simple and with great charm, while there is a dynamic vitality in the enamels of the chrysanthemum and butterfly design around the edge of the dish.

19. *Polychrome enameled vessel, chrysanthemum, peony, and genre design. H. 27.0 cm. Kambara Collection, Arita Historical Museum.*

From the mid-Edo period, during the Genroku, Kyōhō, and Hōreki eras (late seventeenth through mid-eighteenth century), export Imari wares began to be decorated in a Japanese, rather than simply imitation Chinese, style. The vessel pictured here was made at this time as one of a pair and is thought to have been used as a plant pot. The design of peonies and chrysanthemums alternating with female figures is masterfully done.

20. *Cobalt underglaze decorated jug, floral design. H. 23.0 cm. Kamochi Collection.*

21. *Polychrome enameled jug, bamboo, grass, and flower design. H. 24.0 cm. Kamochi Collection.*

The jug in Plate 20 has been given an Oriental look with the main floral motif round the body of the pot bordered at top and bottom by cobalt underglaze decoration of extremely pure color. It seems likely that this type of decoration was felt by Europeans to be Oriental.

The jug seen in Plate 21 is a domestic vessel used at the dinner tables of European families at the end of the seventeenth century. The design round the lip and the base of the pot has been done in order to give the jug a European feeling, while the main design of bamboo, peonies, and chrysanthemums has been painted in minute detail.

22. *Polychrome enameled ewer, landscape design. H. 20.8 cm. Imaemon Antique Ceramics Center.*

This bottle is known as *kendi* in Japanese and would appear to be a variation on a form found in Southeast Asia. Although this type of ware was made in large quantities, in both cobalt underglaze and enameled porcelain, it is fairly rare in Japan, for all such pieces were made for export. The porcelain body, enamel techniques, and luster of the glaze all suggest that this pot was made about 1660, when export production was flourishing.

23. *Polychrome enameled ewer, floral design. H. 21.0 cm. Kurita Art Museum.*

This ewer has had its sides fluted in the *shinogide* style, and the glaze is slightly bluish. The design consists of both spring and autumn flowers—plum, narcissus, peony, and chrysanthemum.

24. *Polychrome enameled, handled and lidded container, chrysanthemum design. H. 17.5 cm. Arita Ceramics Museum.*

This pot is typical of Imari export ware and was probably used for sugar. The body of the pot has been "fenced" with vertical stripes forming a background for bright chrysanthemum sprays. The two handles are purely decorative. The original lid to the pot is missing; the one shown here was made in England.

25. *Polychrome enameled lidded bowl and saucer, flower and bird design. H. 21.0 cm. Saucer, D. 33.3 cm. Kambara Collection, Arita Historical Museum.*

This pot would seem to have been made as a soup tureen; it is particularly valuable as an example of Imari ware that has come back to Japan from Europe, because neither its lid nor its saucer have been damaged in any way. A complex scroll done in cobalt underglaze forms a background to three double lozenge designs of seven treasures and phoenix in overglaze enamels.

26, 27. *Large polychrome enameled jar, Dazaifu design. H. 59.7 cm. Genemon Pottery Center.*

At one time there was a demand, both at home and abroad, for large incense jars in the Old Imari style. These were made in pairs with the same shape and design and were used as decorative pieces. This large jar is painted with a design characteristic of western Japan, with its realistic portrayal of Dazaifu in Tsukushi (present-day Fukuoka). Plate 26 shows the main hall of the Kanze-on Temple; Plate 27 the Tenmangū (Anraku-ji), which was built to honor the Dazaifu administrative authorities.

28. *Polychrome enameled lidded jar, "Southern Barbarian" (namban) design. H. 24.0 cm. Kobe Municipal Museum of Namban Art.*

There are very few Old Imari pieces that show this amount of exoticism. This jar, with its design of a man astride an elephant on one side and a dancing girl on the other, seems to pulse with the rhythm of the music of some South Asian land. The overall appearance of the design is enhanced by the black background.

29. *Polychrome enameled faceted jar, genre design. H. 35.0 cm.*

This jar, with its restful design of three women strolling through a somewhat Chinese looking scene, is reminiscent of paintings found in Edo period picture books. But here the scene is made more realistic by the inclusion of a dog and chickens. These give this lavish faceted jar even more charm. The octagonal shape gives the pot a dynamic feeling, and the lip is marvelously made.

30. *Large polychrome enameled dish, courtesan and "Eight Views of Ōmi" design. D. 41.5 cm. Kambara Collection, Arita Historical Museum.*

This is an extremely decorative large dish with all the lavish charm of a Genroku era (1688–1704) picture book. In its center, in slightly three-dimensional perspective, has been painted a landscape design that is an amalgamation of scenes from the Eight Views of Ōmi; in this landscape a courtesan walks across a bridge with wooden railings. The border of the dish, with its floral honeycomb design in which the red and gold enamels serenely harmonize, is particularly rich.

31. *Large polychrome enameled flat dish, basket of flowers and bird design. H. 54.8 cm. Kambara Collection, Arita Historical Museum.*

Oriental flower basket designs used to be done to satisfy the European taste for chinoiserie, a taste that is fully reflected in the symmetrical design of this dish, with its basket of peonies on a table in the center, and chrysanthemums and pinks to right and left respectively. The border of the dish has been painted with a rock, peonies, and chrysanthemums, together with two phoenixes. The dish itself is perfectly formed.

32. *Polychrome enameled irregular dish, festoon (noshi) and arrow design. 30.5 × 19.4 cm. Tanakamaru Collection.*

During the years of peace that characterized the Edo period, ceremonies, such as those marking the blooming of the peach in spring and the iris in early summer, were kept with great care and attention, and from about the eighteenth century (mid-Edo period) Old Imari polychrome enameled celebratory dishes like the one here were made. Since the iris festival was in honor of boys, this kind of bow and arrow motif was designed to go with the sets of warrior dolls that were displayed at that time. The *noshi* festoon motif is exquisite.

33. *Large polychrome enameled lidded jar, flower-and-bird design. H. 47.0 cm. Kurita Art Museum.*

This lidded jar may be more decorative than functional, but its full form is majestic. The body and lid of the jar have been painted with rich chrysanthemum and peony designs in the "window" style. The cobalt underglaze, polychrome enamels, and overall glazing are magnificent, while the lid has been superbly sculpted.

34. *Large polychrome enameled vase, peony, Chinese lion, and sacred bird design. H. 82.0 cm. Kambara Collection, Arita Historical Museum.*

The design on this large polychrome enameled piece shows how exotic Oriental taste could in fact harmonize with baroque architecture and rococo interior design. The pigment of the underglaze is somewhat on the black side, but on the other hand, it forms a striking contrast with the enamel colors.

35. *Polychrome enameled lampstands, flower and basket designs. Left, H. 59.0 cm. Kambara Collection, Arita Historical Museum.*

These are splendid European copies of export Imari ware. It is impossible to tell whether these originally were made as lampstands, but they may well have been, for the shoulder of the pots above the beveled body seems perfectly suited to take the lamp apparatus. The "window" style designs of rock, peonies, and a flower basket are in perfect harmony with the rectangular bodies of the stands.

36. *Polychrome enameled bowl, "five ships" design. D. 36.4 cm. MOA Museum of Art.*

Generally speaking, "Southern Barbarian" (*namban*) style paintings—among which the "red hair" Imari wares are usually classified—are portrayed in an extremely decorative manner. A design like this was not made for export, but was applied to luxury wares for the residences of samurai lords or wealthy merchants in Japan. The bowl has three Western style ships on the inner surface and two on its underside, thus the design's name.

37. *Cobalt underglaze decorated bowl, foxtail millet and quail design. D. 20.8 cm.*

Examples of this foxtail millet and quail motif can be found frequently on Hizen porcelain wares right through from the beginning to end of the Edo period, but a number of stylistic changes occurred over the years. This particular bowl is late Edo period, made for everyday use at the Arita Sotoyama kiln. Produced at a time when Hizen porcelain was finally coming to be used in people's everyday lives, the design is lighthearted and popular and slightly humorous.

38. *Cobalt underglaze decorated plate, pine tree and crane design. D. 22.3 cm.*

The plate pictured here has been vivaciously painted with a popular, felicitous design of pine tree and crane, which looks almost like a dark blue curtain. The whole plate is imbued with a healthy functional beauty and would seem to have been produced for mass consumption at the Arita Sotoyama kiln in the late Edo period.

39. *Polychrome enameled oil jars. Back row: left, H. 5.0 cm., D. 9.1 cm.; front row: left, H. 6.2 cm., D. 9.6 cm.*

By the fifth and sixth decades of the eighteenth century, in the late Edo period, all sorts of wares were being produced as public demand for porcelain increased. Jars like these were placed by women's mirrors. The variety of the designs painted on these intimate oil jars is extremely attractive.

40. *Polychrome enameled figurine. H. 46.5 cm.*

This is one of the better examples of Old Imari figurines and was probably modeled after an original Hakata or Kyoto doll design. The collar of the girl's kimono has been done in what might be called the hallmark of Old Imari wares, while the hem has been brushed over with a deep, thick red. Gold has been added to accentuate the collar. Above all, the girl's smiling expression holds great charm.

41. *Pair of polychrome enameled figurines. Left, H. 18.0 cm. Kambara Collection, Arita Historical Museum.*

One is struck by the liveliness of these folk figurines, which were probably inspired by a village festival or saké party. The figures have been decorated with overglaze enamel only, in red, gold, and green, blue, and black, and the floral patterns on their clothes are beautifully simple.

42. *Large cobalt underglaze decorated plate, map of East Asia. D. 52.1 cm. Saga Prefectural Museum.*

During the last part of the Edo period, scenes from the picture books of that time were painted on large Arita underglaze decorated plates. Some of these had maps both of Japan and of the world, thereby reflecting perhaps the heightening interest of people in foreign culture. These maps usually placed Japan at the center. What is particularly interesting about this plate is that it records distances in *ri* between Japan and foreign countries. A fairly large number of such map plates were produced during the Tempō era (1830–44) at the end of the Edo period in the valley kiln of Ōhōyama in Arita Sotoyama.

定価3,200円
in Japan

DATE DUE

DEMCO 38-297